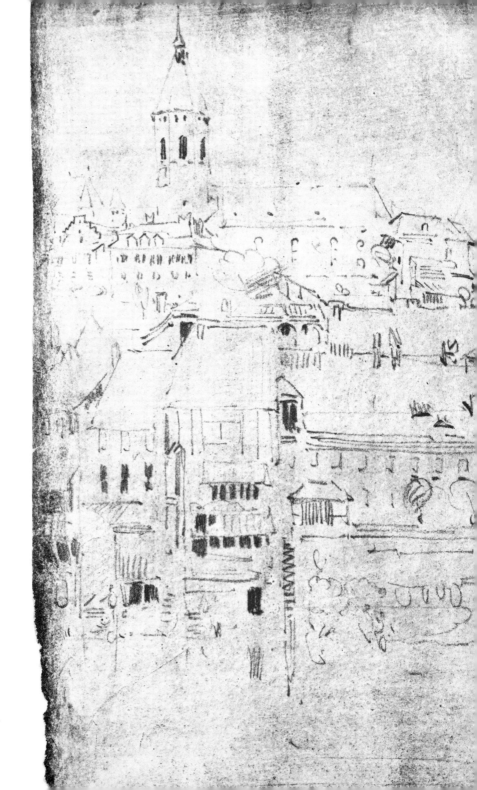

The town of Thun, 1802
from the 'St Gothard and
Mont Blanc' sketchbook.
Turner Bequest no LXXXV, 30.
18 × 12 inches

Turner Sketches 1789–1820

Gerald Wilkinson

BOOK CLUB ASSOCIATES LONDON

by the same author

Turner's early sketches 1972 reprinted 1975
The sketches of Turner, RA 1974 reprinted 1975
Turner's colour sketches 1975

This edition published 1977 by
Book Club Associates
by arrangement with Barrie & Jenkins

ISBN 0 214 20418 9 (Cased edition)

ISBN 0 214 20387 5 (Paper edition)

Text copyright © Gerald Wilkinson 1977
First published in 1977 by Barrie and Jenkins Ltd
24 Highbury Crescent, London N5 1RX
Printed by Sir Joseph Causton & Sons Ltd
London and Eastleigh
Colour reproduction by Colour Workshop Ltd, Hertford

Preface

All the sketches and drawings are reproduced by permission of the Trustees of the British Museum. The drawings are part of the Turner Bequest and were catalogued in the early years of this century by H. J. Finberg. He gave a Roman numeral and a name to each sketchbook and group of drawings, and numbered the leaves, not usually the pages, of the sketchbooks in arabic numerals. Thus a drawing from the sketchbooks may have a number like XXXV, 83a 84, indicating that it occupies two facing pages of sketchbook number 35. Separate sheets of drawings usually have a letter rather than a number, thus: CXCVI, E.

The dimensions given are those of the pages, spine first, thus.

$4\frac{3}{8} \times 7\frac{1}{4}$ $7\frac{1}{4} \times 4\frac{3}{8}$

I apologise to readers who are happier with centimetres: the scale on this page will help. Most of the reproductions are a little over half size, very small pages being nearly full size and large pages, necessarily, much reduced. Turner's labels and titles are given in *italics*.

In adapting two larger books to one small one I have had to allow some drawings to bleed off the edges of the pages. The loss is usually less than $\frac{1}{8}$ inch, or about $\frac{1}{4}$ inch of the drawing. I have had the rare luxury of being able to reconsider my text—I hope to some advantage, particularly in taking account of several excellent books which have appeared since these sketches were first published.

In the Preface to *Sketches of Turner, RA*, I claimed that to select more rigorously would be to risk distorting the representation of Turner's enormous output of sketches. Now that book of 190 pages has been compressed into 70 of this one I am happy to say that I think the image of the master remains intact.

We hope to produce a further volume of the later sketches.

Chipping Norton, 1977

Contents

Books

W. G. Rawlinson 1908, 1913 *The Engraved work of J.M.W.T., RA* Macmillan

A. J. Finberg 1909 *Complete Inventory of the Drawings of the Turner Bequest* HMSO
 1924 *Turner's Liber Studiorum* Benn
 1961 *Life of J. M. W. Turner, RA* 2nd Edn OUP

James Greig (ed) 1922 *The Farington Diary* Hutchinson

Martin Butlin 1962 *Turner Watercolours* Barrie & Jenkins

Rothenstein and Butlin 1964 *Turner* Heinemann

Jack Lindsay 1966 *J. M. W. Turner: his life and work** Cory, Adams, Mackay
 1966 *The Sunset Ship* (Turner's verse) Scorpion Press

John Gage 1969 *Colour in Turner* Studio Vista

Graham Reynolds 1969 *Turner** Thames and Hudson

*Turner 1775-1851** Catalogue of the Bicentenary Exhibition at
 Burlington House, Tate Gallery Publications ('RA 1974' in our text)

Andrew Wilton 1975 *Turner in the British Museum** British Museum Publications

Luke Hermann 1975 *Turner* Phaidon

Walter Amstutz, John Russell, Andrew Wilton 1976 *Turner in Switzerland*
 de Clivo Zurich

* *available in paperback*

FOR KURT PANTZER

Sketches, drawings, and 'blots'

This book contains a comprehensive selection of the illustrations from the first two (of four) volumes devoted to Turner's sketches and sketchbooks. Most of the material had not been reproduced before. The only previous study of Turner's sketches was by Finberg: *Turner's Sketches and Drawings,* printed in 1910 with 100 illustrations. Most recent writers on the artist have of course referred to the sketches and have usually reproduced a handful. Alan Reynolds, whose *Turner* (1969) must be regarded as the standard short biography, gives equal importance to sketches, drawings, watercolours and paintings, while somewhat neglecting the engravings. The latest Turner monument, the Phaidon book by Luke Herrmann, reproduces 34 sketches, apart from oil sketches.

In Turner's work a sketch can be a spidery note, or a carefully pencilled architectural or landscape composition. It may be a brilliantly evocative brush drawing, or a study in any medium for a projected picture. Some sketches are perfect miniatures, like the famous 'French Rivers' and Petworth gouaches, and many less well known. Some of the later watercolours, as great and as idiosyncratic as

10

the last quartets of Beethoven, are sketches at least in the sense that they were not 'finished' for sale or exhibition. There are also many important oil sketches, not the subject of this book.

What is a sketch? Today the term may be quite meaningless: 'sketching' merely suggests amateur landscapists. Most painters make exploratory drawings before starting an important canvas (or whatever 'environmental situation' they work on). These explorations will be rejected or preserved according to their intrinsic value as drawings. All, or very nearly all, of Turner's drawings are preserved, and it is for us to evaluate them – not, as the puritanical Finberg warned us, strictly in relation to exhibited work, but for their own sake as drawings. They have also a special meaning, in the relatively ordered chronography of the sketchbooks, as biography, and an extra dimension as aids to the understanding of Turner's creative process. So, while many people will define a sketch as merely a rough draft, in the context of Turner and his time (the same is true of Constable) a sketch must mean any work not 'finished' for exhibition or sale. There are some arguments for valuing the unexhibited work more highly than the exhibited: these are, briefly, that it is free of adaptions to public or academic taste and that it is often better preserved; for oil paintings start to decay and darken from the moment they are hung, and carelessly exhibited watercolours fade and go yellow.

In the late Georgian period a sharp distinction was made between unfinished and finished work, and exhibited work was expected to be finished in both senses, physical and conceptual. An interest in the quality of say, a chalk drawing, was considered to be flippant by the serious academic artists. None the less, people enjoyed drawings, and there was a thriving market for reproductions of them – stipple engravings in the 'crayon manner', soft-ground etchings, mezzotints. Aquatint, as its name suggests, originally an imitation of watercolour drawing, rose from its first use in 1750 to become the most popular form of graphic reproduction at the end of the century.

'Smudges' and 'blots' and other spontaneous effects were frowned upon by serious

Blot drawing by Alexander Cozens, engraved in his *New Method for Assisting the Invention*, 1785

painters. Even watercolours had a hard time of it at the Royal Academy Exhibitions – they were crowded into the darkest rooms, and not dignified by the name of painting.* The Society of Painters in Watercolour (later the RWS) was started in 1805 as a very successful competitor, and its moving spirit was W. F. Wells, a close friend of Turner's. J. M. W. himself, a staunch Academician, produced hundreds of 'finished' watercolours of the utmost brilliance and richness, firmly establishing the medium as the equal of oil in spite of the association it still has with young ladies dabbling under sunshades.

Turner's technique in watercolour was not 'pure'. He scraped and scratched, he wiped out (most skilfully) and 'soaked' and added opaque white, sometimes to washes and particularly in jewel-like spots and touches. He sometimes even used the pen, with coloured or black ink. Unfortunately very many of the watercolours sold during his lifetime have been exposed to too much light and have lost their blues. The sketches show that he was also master of the pure, direct technique which became the style of the English school of Watercolour in the hands of Cotman, Cox and de Wint. Turner and Girtin were really the founders of this school, with J. R. Cozens, Paul Sandby and Francis Towne as its precursors.

The Academy's distrust of watercolour arose partly from the fear of cheap effects under-mining their orthodox and well organised work, and partly from professional snobbism. Watercolour was associated with popular topographical art, and, while Sandby and Farington, elders of the Academy, did little else but topography, the highbrows like Fuseli (professor of painting 1799–1805) and Loutherbourg would use the adjective 'mappy' of any landscape which seemed too objective, too unregarding of classical canons or insufficiently 'sublime'.

Beside the topographical tradition, with its roots in the military drawing academies, flourished the 'picturesque'. Ruins might be both picturesque and topographically correct, while views collected on the Grand Tour had the automatic advantage of classical overtones. Picturesque art looked towards

* Watercolours are usually 'drawings' but can be technically paintings if so conceived and executed.

Italy and had its chief expression in the organised untidiness of landscape gardening. The insular picturesque artists however were associated with prosy descriptions and 'smudgy' aquatints based on amateurish sketches. All the same, some very good artists worked under both or either of these persuasions, among them the young Turner.

In spite of their haughty attitudes the Academicians had no glorious tradition of landscape painting in oils, and this in a country renowned for the beauty and wide range of its landscape. Connoisseurs bought Salvator Rosa, Claude and Van de Velde. Richard Wilson, an early hero of Turner's, had died in neglect; Gainsborough had more or less given up landscape for portraiture, to make a living; Morland was really a genre painter, Loutherbourg too Swiss and 'scenic' to be a true English landscapist. The Academy would have done well to encourage the water-colourists and artist-engravers, many of whom it had trained in its own schools, even if it could not, at that time, tolerate chalk and pencil sketches for exhibition.

Turner's attitude to finished and unfinished work was certainly influenced by the standards of his time, but he seems to have wanted to show works which were not finished to the standard required by the RA, for he opened his own gallery in 1804 while continuing to send in to the Academy. He certainly exhibited some wash drawings at his own gallery – the *Liber Studiorum* drawings in 1807, noticed by one David Cox, seven years his junior. He also showed some of his oil sketches, if we can go by the comments at the time: 'Views of the Thames – crude blotches', said Benjamin West, the PRA, after he had visited the gallery. 'Like a green stall', said another, while Sir George Beaumont, Turner's most belligerent critic, remarked on 'strong skies, and parts not corresponding to them'. These green blotches with strong skies have serenly outfaced their contemporary critics.

These possible examples apart, all Turner's experimental work, nearly 20,000 pieces including the pencil sketches, accumulated in concealment throughout his long working life. There are no contemporary accounts of them, save two. He once, and I believe only once, gave an unfinished sketchbook to

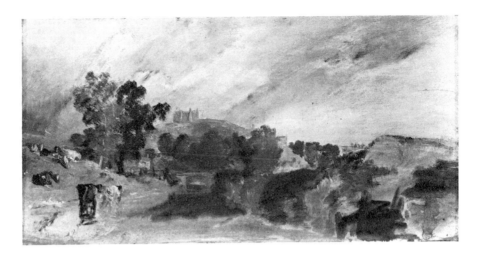

a friend (the gentleman-painter Munro of
Novar, in 1836) and he did show two of his
sketchbooks to Joseph Farington, who had
befriended him. Turner was canvassing votes
for his Associateship and discussing with
Farington the possible advantages of 'placing
himself in a more respectable situation'
(finding somewhere better to live). The diarist
RA noted in October 1798:

I afterwards called upon him at his father's,
a hair dresser, in Hand Court, Maiden Lane –
the apartments to be sure, small and ill-
calculated for a painter. He shewed me two
books filled with studies from nature – several
of them tinted on the spot, which he
found, he said, were much the most valuable
to him. One of the books contained studies
made at Malmesbury, Chepstow [etc. –
Finberg identifies the 'Hereford Court'
sketchbook]. The other book, studies at
Doncaster, York, Durham, Melross, The
English Lakes [etc. – the 'Tweed and
Lakes' sketchbook].

He requested me to fix upon any subject
which I preferred in his books, and begged
to make a drawing or picture of it for me.
I told him I had not the least claim to such
a present from him, but on his pressing it I
said I would take another opportunity of
looking over his books and avail myself of
his offer. – Hoppner, he said, had chosen a
subject at Durham.

Hoppner, he told me, had remarked to
him that his pictures tended too much *to the*

brown and that in consequence of that
observation he had been attending to
nature to enable him to correct it.
Farington, with Smirke, again 'looked over'
his sketchbooks in 1799.

Turner must have shown certain pages of
his larger sketchbooks to patrons after these
early occasions for he made careful preparatory
drawings for 'house portraits', such as
Petworth . . . Dewy morning and *Tabley . . .
Calm Morning,* which he did not do for other
paintings. The reason must have been to
ensure that the patron knew what to expect.

He numbered all his books (according to
some system that has not become clear) and
built them up into a private reference library –
there were nearly 300 in the end. Thus he
was able to produce new pictures, for instance
for engraving in the *England and Wales* series
around 1830, from material collected as long
ago as 1797. When he was asked to go to
Scotland in 1831 to illustrate the complete
edition of Sir Walter Scott he was reluctant
to travel – he had, he wrote, '68 of the subjects
already in my sketchbooks'. Most of these
would date from 1802. Happily, he did go again
to Scotland, and me made a friend of Scott.

The sketches

For our purpose, and certainly up to 1820,
a sketch by Turner may be one of several
things. It may be a rapid note in pencil of
architecture or scenery – these are the majority.

9

It may be a most excellent piece of careful drawing, to be used in an accurate topographical work or a gentleman's seat. The final work would be a great deal more than a plain record, from its conception: but Turner liked to get his details right. With, for instance Fonthill (1799) and Raby Castle (1817), the subjects of several large, detailed studies, the house appeared quite small in the final paintings.

The pencil sketch may also be something between a rapid note and a careful record. Some of his best travelling sketches have this nice balance between economy and accuracy, like the church at Loretto reproduced here.

He also used his pencil to make small 'visuals' of the pictures he planned – sometimes the painting is surprisingly close to the pencil miniature – see the *Battle of Trafalgar* sketch on p 106. If no pencil were handy (this was rare!) he could as easily use the pen with which he wrote his many rather awful verses: see the *Tabley: Windy Day* sketch on p 115. Again, the pencil poised for linear

reference notes would often become expressive of atmosphere in some evocative cloud study or subtly tonal landscape. These minuscule grey 'Turners' amongst the pages of everyday line-work are a great part of the charm of the sketchbooks.

He used his sketchbooks for all sorts of experiments with wash, chalk, and, especially in the early years, watercolour. Only rarely he seems to have removed a page to finish it as a separate picture (though several were dismembered, by Turner or his executors, and have been reassembled by Finberg, in the process of compiling his great *Inventory*). There are many half-completed watercolour drawings in the sketchbooks and amongst the assorted sheets he accumulated, and these are of special interest in showing exactly how he worked and developed his ideas.

In his sketchbooks, particularly in the small notebooks, one of which was always in his greatcoat pocket, he also did his accounts, and he wrote out itineraries, lists of works and patrons, copied recipies, planned his new

A pencil sketch of 1819 The Church of the Casa Santa, Loretto. Turner Bequest no. CLXXVII, 12. 4 × 7 inches

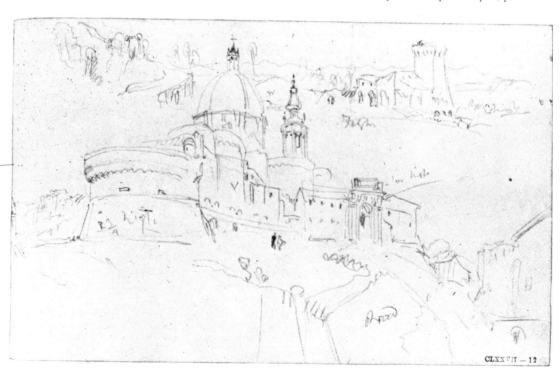

house, and composed verses. On one amusing page he listed his own clothes (p 61).

A special class of sketchbooks of various sizes contain cheap blue paper for the rapid working out of compositions in black and white chalk – and in two of the early books, one with brown paper, in pastel. These books are often labelled *Studies for Pictures* in Turner's hand. The earlier sea pieces, particularly, often went through several stages of development in this manner. There are many attractive seascapes which exist only in this form of chalk calligraphy. Turner's handling of ships and sails is always irresistable.

Besides using tinted paper he frequently tinted his own Whatman in various uneven greys and browns – in the case of the Dunbar book (pp 74–76), in pink. The method enabled him to scratch out his lights – it is said, with a specially grown and sharpened thumbnail. He was happy often to work transparent watercolour into his tinted ground – indeed he was as skilful at removing pigment as he was in applying it.

Not precisely sketches, rather working drawings, are the pen and wash drawings in brown which Turner produced for his *Liber Studiorum* mezzotints, published between 1807 and 1819. The subjects for this wordless treatise on landscape occupied him greatly and very much extended the scope of his art, and of course his sketching. The shaded pencil drawings on page 107 are rudimentary *Liber* plates. The process of etching the plates in turn influenced his pencil line. Insufficient attention recently has been paid to these and other engravings which, the sketchbooks clearly show, were as important a part of his work as his painting. He began as a topographical illustrator, and it was as an illustrator that he worked for at least half his time up to the age of 60, though of course he raised the art to a level not known before. He could be illustrative without being literary. It is true to say that commissions for engraving were the reason for the splendid range and abundance of his sketches. When he travelled, as he did in our period, to Switzerland and Italy, not to find subjects for engravings but to enlarge his own understanding of art and landscape, the habit persisted of noting in pencil all that interested him or that might be useful. Drawing became a way of seeing.

Turner's draughtmanship

He always had a pencil in his hand when travelling. He evolved his exact yet lively line through several stages which can be followed in this book, from the early hooks and spots of Marford Mill (p 21) through much careful architecture to the vigorous scribbling of the Scottish Lakes book (pp 80, 81) and the more relaxed, sinuous line of the 1802 journey through France to Switzerland. This is to over-simplify, for these rapid lines were only one of his sketching styles. On his arrival in Switzerland we find him attacking the mass and tone of the mountains in a series of wild and expressionistic chalk drawings which formed the basis of the somewhat heavy watercolours in what Ruskin called Turner's 'Alpine style'.

He often reverted to his calligraphic or snaky line, with its convolutions suggesting masses rather than shapes. The Thames drawings on p 109 are examples. There is perhaps a connection between these arched and elliptical lines and the vague, rounded forms in some of his later paintings, with their mushroom-shaped trees and melting coastlines. If we trace back the looped calligraphy to the pothooks learnt from (perhaps) Canaletto via Dayes (Girtin's master – Girtin also had the style), we have an interesting demonstration of consistency in works apparently poles apart – and a hint that Turner may have begun his dissolving of the outline quite early in life.

But line, so strong an element of English art, is capable of great expression. Only outlines are fictitious. In producing, himself, the etchings which were the bones of his *Liber Studiorum* plates (others usually scraped the mezzotint tones over his bitten lines) his wrist seems to have stiffened, and his pencil line after about 1810 gains a new incisiveness. We see it in the state barges of the Thames (p 103), in the townscapes and rocks of Devonshire (pp 130, 131), the saplings of Farnley (p 139) and the beech trunks of Raby (p 146); and we are conscious of it in the deliberate, sensitive shading of Bolton Abbey (p 137) as in the exuberance of Venice (p 155). This is Turner's mature draughtmanship, and there is none better. He is also capable of a more searching and less confident

attack as in the curiously modern-looking *Kenchaus* (p 79) and the facing page, and in many later sketchbooks.

His subjects

In the period following his return from Switzerland in 1802, up to 1811, he travelled very little. It was a time of hard work in many different genres, all far removed from the dazzling polychromy of later years. Colour, unless it is the resonant harmonies of the old masters* interests him less than light and shade, the geometries of composition, movement, contrast, wind and weather, the nature of land and sea, the pathos of man, the pervasive glow of classical sunsets (a la Claude), the play of summer light on the willows of his favourite Thames, the shapes of boats and, always, the patterns of clouds. These are the true themes of the *Liber Studiorum,* not the categories he used to hang them on, and they are the themes of all his work up to 1811.

Then, inspired by a new commission to draw the scenery of the *Southern Coast,* he cast away from what may have been – we do not know – a troublesome domestic life. Instead of boating on the Thames he tramped the cliffs of Devon and Cornwall in 1811 and 1813, and, renewing his friendship with Fawkes of Farnley, the Dales of Yorkshire. Fawkes commissioned a long series of watercolours, and another series for the publishers of *Richmondshire* kept him on the move in 1816. Eventually escaping, in 1817, from the immediate demands of illustration, he travelled to Waterloo, the Rhineland and Holland, again collecting hundreds of pencil notes, but producing also a magnificent series of fifty watercolours which show him at last both mature and free as a painter. The same qualities emerged somewhat later in his oil painting, but the *Dort* or *Dordrecht* of 1818,

which grew out of his studies of calm at sea, his admiration for Cuyp and perhaps, characteristically, from the challenge of a similar subject by his friend Callcott in the previous year's Exhibition, provides a glimpse, through its gleaming, translucent sea and sky, of what was to follow. This painting, at once a synthesis of his previously acquired pictorial skills and a sign of future power, may be seen as the fulcrum balancing Turner's earlier and later achievements.

Pencil drawing continues always as the ground bass of all Turner's various work; through it he absorbs what he needs – and much more than he seems to need – of his visual surroundings, and with the pencil he gives form to his ideas and plans his compositions. Even the *Dort* picture, apparently with distinct forebears in art, has its conception in life, as we see from the small pencil from the 'Itinerary, Rhine' sketchbook (p 141).

Into the sketches Turner crammed everything that interested him, and from them he reconstructed all his observations and ideas for his very large and varied output. All routes cross in the sketchbooks, and often enough a small masterpiece is lodged there and preserved, as fresh as the day it was done.

'Every glance', he told his perspective students, 'is a glance for study'. But his study and observation were matched by activity and production. If we cannot always see the reason for page after page of pencil notes, we can be sure that *he* had a reason.

The copiousness of his pencilwork is nowhere more evident than in the Italian sketchbooks of 1819. At the age of 44 he at last found himself free to visit Venice and Rome. Not a moment of his journey, lasting two months, or of his stay in Rome of about three months, can have been wasted. He filled sixteen small sketchbooks with nearly 2000 pencil drawings and five larger books are in chalk, pencil and watercolour. Nor did he relax on the wintry journey home, as he hurried to begin his large 'homage to Raphael', *Rome from the Vatican*, for exhibition at the Academy in April, 1820.

* 'Old master colouring' was an obsession of the young Turner – and of all the Academy painters. The 'Venetian Secret' scandal of 1797 involved a student, Mary Ann Provis, who was exposed for charging ten guineas for a formula, supposedly derived from Titian, which didn't work. Several prominent Academicians were duped: Rigaud, Stothard, Hoppner, Opie and Farington among them.

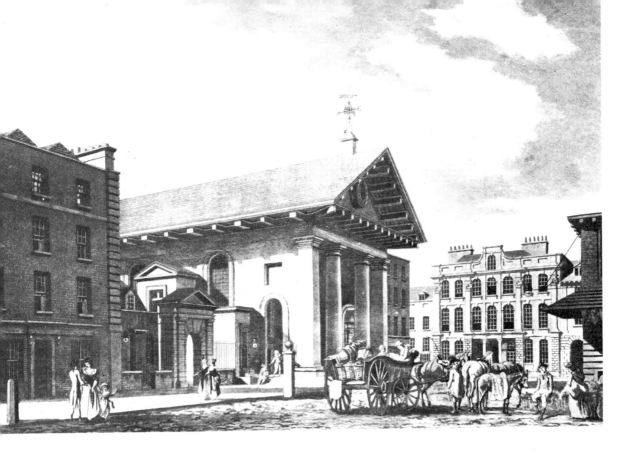

Covent Garden

St Paul's, Covent Garden, designed by Inigo Jones, is the earliest Italianate Church in England (1630, rebuilt in the eighteenth century). The mezzotint of 1792, is by Thomas Malton, who was Turner's teacher. St Paul's was the Turners' parish church. It contains a memorial stone to William Turner placed there, and probably engraved, by his son J.M.W.

Turner the painter was born in 1775 in Maiden Lane, which is between Covent Garden and the Strand. His father, William, who was a barber and wig-maker, came from Devon, and had married Mary Anne Marshall of Islington when she was 34 and he 29. Mary had a brother, Joseph Mallord William, a butcher in Brentford, and when her son was born two years after her marriage she gave him these names. But he was called plain William and signed himself so until he was 27.

He had a younger sister who died at the age of eight, in 1786. The year before this the boy was sent to stay with his namesake uncle – Brentford is about twelve miles up-river. One of the earliest surviving Turner sketches is of Brentford church, and others were made around Abingdon, near Oxford, where his uncle had another house. The earliest drawings are mostly copies from engravings and are signed *W. Turner 1787,* showing that, at the age of twelve he had already a sort of professional pride.

The only ordinary schooling that we know he had was at Brentford Free School where he attended for perhaps a year or more. For his education in art, many claims have been made for the honour of providing the formative influences of the greatest British painter. Thomas Hardwick, the architect of Wanstead church and in charge of the re-building of St. Paul's Covent Garden, possessed some of his drawings, and this gave rise to the idea that Turner was Hardwick's pupil. He was not, but Hardwick, whose family lived at Brentford, may have guided the boy into an early connection with

architecture. There are at least two unprovable accounts of his colouring or adding skies to architects' perspectives, and his first true master, Malton, was an architectural illustrator.

Turner's first biographer, the engraver John Burnet, wrote in 1852 that he 'found employment while yet a mere boy in colouring prints for John Raphael Smith, the crayon painter and engraver (in mezzotint), then residing in King Street, Covent Garden. Another of Smith's assistants at this time was Thomas Girtin.' Girtin was the same age as Turner.

The area of Covent Garden and the Strand was a fashionable part of London – extending to Somerset House, which housed the Royal Academy, to the east, and St. Martins and Soho to the west. Wig-makers, perfumers, drapers, habit-makers, hatters, and book-sellers, print sellers, engravers of all kinds, and painters of every degree, were thick upon the ground. Zoffany and Stubbs were in the Great Piazza of Covent Garden. Wilson had also lived there. Maiden Lane itself contained in the late eighteenth century at least two engravers: Anthony Vere, seal engraver and jeweller, and at the sign of the Gold Frame, John Woodifield, plate engraver. At no 21, where Turner was born, an auction room had been leased to the Free Society of Artists for their exhibitions in 1775 and 76, and the same room had been used for drawing classes attended by Romney, Wheatley, Farington and others. Below stairs was an old-established tavern, the Cider Cellar, described also as a 'midnight concert room' (Jack Lindsay). The Turners later moved to no 26, opposite.

The boy Turner lived in fact in the fashionable artists' quarter of London. Topographical and picturesque engravings, as well as Raphael Smith's copies of Reynolds, were familiar to him from his earliest years. Publishing and engraving, and the busy London River – and popular songs and glees from the tavern at midnight – then the Thames-side country at Brentford and Abingdon: these were his earliest impressions. Ruskin insisted on the squalor and congestion of Maiden Lane; that Turner, in Coleridge's words, 'hungered after Nature, many a year, in the Great City pent . . .' He may have done later, stuck in his studio on dark winter days, with his *Liber* plates or a difficult canvas, but it is likely that as a boy he found it easy to escape up or down river, crouching, as Ruskin has him, in the bows of a wherry, 'quiet as a log'. He had only to walk a mile to the top of Tottenham Court Road to find fields and cows. In any case, it is doubtful whether Maiden Lane was squalid. It must have been more like, say, South Molton Street today. It obviously deteriorated in mid-Victorian times, on the way to its present aridity.

Ruskin also dwells on the vegetable rubbish of Covent Garden Market as an inspiration for Turner's often littered foregrounds. But Covent Garden serving a population of less than one million (quadrupled by the time *Modern Painters* was written) need not have been so messy. The Floral Hall was built to contain the market. Malton's aquatint may be unnaturally tidy, all the same.

Thornbury, the very unreliable author of the first full-length biography of Turner, says that after a year at Brentford, Turner was sent to a Mr Palice, a 'floral' drawing master, at an academy in Soho – which may or may not be true – and 'before 1788' he was sent to Thomas Malton in Long Acre 'to learn perspective'. That he did study under Thomas Malton junior is certain, because it is recorded more contemporaneously by Farington, and Turner's work about 1790–1792 shows the influence of Malton. The master may have assisted Turner with his earliest exhibited works, particularly with the figures. Malton's impeccable but rather hard-edged and steep architectural perspective and his over-elegant figures are quite evident in the first drawing Turner showed at the Academy, *The Archbishop's Palace, Lambeth* (1790) now at Indianapolis, or in *Bath Abbey from the North East* (1791), but they are quite gone by the time he draws *Tom Tower, Oxford* in about 1793. The last two drawings are in the British Museum. When Turner, later, became Professor of Perspective at the R.A., he made full use of Malton senior's treatise on perspective.

Another important influence on Turner's early drawing was that of Edward Dayes, to whom Girtin was formally apprenticed. There is supposed to have been a terrible quarrel between Girtin and his master which

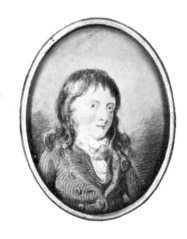

Self-portrait of Turner, aged 14, National Portrait Gallery

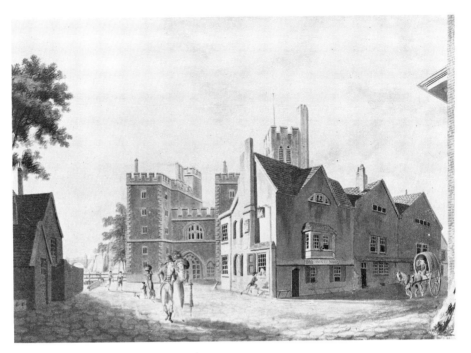

ended the apprenticeship and landed Girtin in prison. According to Edward Edwards, ARA, Dayes' temperament was 'neither amiable nor happy'. He committed suicide at 40 (in 1804) leaving a collection of rather catty short biographies of his contemporary artists. Of Turner he wrote:

Highly to the credit of this artist, he is indebted principally to his own exertions for the ability which he possesses as a painter, and for the respectable positions that he holds in society. He may be considered as a striking instance of how much may be gained by industry, if accompanied with temperance, even without the assistance of a master. The way he acquired his professional powers, was by borrowing, where he could, a drawing or picture to copy from, or by making a sketch of any one in the Exhibition early in the morning, and finishing it at home. By such practices, and by a patient perserverance, he has overcome all the difficulties of his art; so that the fine taste and colour which his drawings possess, are scarcely to be found in any other, and are accompanied by a broad, firm chiaroscuro and a light and elegant touch. The man must

be loved for his works; for his person is not striking, nor his conversation brilliant. He was born in Maiden Lane, Covent Garden, where his father conducted a decent trade. Though his pictures possess great breadth of light and shade, accompanied with a fine tone of colour, his handling is sometimes infirm, and the objects are too indefinite: he appears, indeed, to have but a superficial notion of form.

It may seem odd that Dayes should stress Turner's self-education, but I suppose that the casual tuition of Malton and attendance at the Academy Schools did not amount to anything approaching the discipline of formal apprenticeship.

Another topographical artist who influenced Turner in the early 1790s was Thomas Hearne. Andrew Wilton detects this influence in a drawing of *Christ Church, Oxford* dated 1794: 'Turner mimics his manner almost exactly, but infuses into it a grandeur which Hearne usually misses'.

Hearne was a much admired friend of Dr Thomas Monro, who employed young artists, among them Turner and Girtin, to sketch outdoors and to copy watercolours lent to

him for that purpose. Monro was himself a moderately gifted amateur. Professionally he was in charge of Bethlehem Hospital (Bedlam) and a private nursing home for the mentally sick, where patients might have 'those various indulgences that mitigate the sufferings of disease, and the severity of indispensable restraint'. (*Observations of Dr Thomas Monro*, quoted by Gage in the Tate Bicentenary Catalogue 1974.) J. R. Cozens was in his care from 1794 until Cozens died in 1797 without recovering his sanity. Turner and Girtin were employed by Dr Monro to copy Cozens' sketchbooks, full of pencil 'outlines'. It is said that Girtin did the lines while Turner added blue and grey washes. Turner in 1833 bought back 172, if not more, of these tinted drawings, 'realisations' rather than strict copies. They are now in the Turner Bequest.

It cannot be said that the young artists realised the Cozens pencil notes to their full potential. (It is sad that Monro could not, instead, give Cozens the power to finish them himself.) The fact that most of the finished drawings were mounted in albums according to subject suggests that Monro's interest was mainly topographical. But Turner must have seen some of Cozen's best watercolours as well (before he acquired one in 1797) and this early intimate contact with his work must have influenced him. His sketchbooks before 1801 show that he had absorbed Cozens' powerful feeling for the darker moods of landscape and his sense of the unity of earth and sky. His habit of accumulating pencil 'outlines', to be filled out with colour when and if required, may have been learnt from Cozens. Even as late as 1828 he referred to Cozens, probably from memory, for a vignette design of Paestum (*Turner's Colour Sketches*, p 40). Such an influence goes deeper than a temporary imitation of manner. I have always regarded J. R. Cozens as Turner's spiritual father, and the fact that Turner's real mother was also mad and ended her days in Monro's care lends a gloomy credence to this idea.

Also among Monro's friends was Loutherbourg, from whom Turner learnt a great deal. His wreck and storm pictures, his later exploitation of industrial scenes, some early crags and cliffs, even his first painting, *Fisherman at sea,* may have derived from Loutherbourg. Besides being an excellent technician on canvas and paper, Loutherbourg was a scenery designer and the impresario of a moving panorama with sound effects called the Eidophusikon. Dayes and Girtin also produced panoramas, and Turner, who was certainly interested in such transparencies, may have been the designer of a display, the *Blowing Up of L'Orient and Battle of the Nile,* on view in 1799.

Thornbury's story that Loutherbourg's wife suspected him of stealing her husband's secret rings true, but the relationship between the two artists was probably in the nature of a friendly exchange, over several years.

The young Turner venerated above all Richard Wilson, until he adopted Claude as his master in the early 1800s. He titles a sketchbook of about 1797 as *Studies for Pictures* (and) *Copies of Wilson*. At the age of 72 he wrote to Hawksworth Fawkes of what he had felt of the grandeur and beauty of Welsh scenery, 'in the days of my youth when I was in search of Richard Wilson's birthplace'.

Turner in the Academy Schools

Since December 1789, when he was still only 14, Turner had been a student at the Royal Academy. J. F. Rigaud is supposed to have helped him to apply. Entry was by submitting a drawing; if this was approved the student was 'permitted' to make another drawing from the Academy's collection of casts from antique sculpture. This drawing was put before the council to confirm his admission. He could then work in the Plaister Academy until he was judged to be ready for the living model. A student had to be 20, or married, to draw from the female nude. Turner graduated to the life class in June 1792, and was presumably restricted to the male model for two years.

Tuition at the schools cannot have been intensive. The Keeper in Turner's time was Joseph Wilton, an aged sculptor. There were Visitors, appointed month by month from the ranks of the Academicians. The President was the American Benjamin West, who always wore his hat in the Academy, but occasionally we are told, got his ruffles dirty rubbing out a student's work. The Professor of Painting was James Barry, who, wrote Edward Edwards, Teacher of Perspective, 'took less pains to

instruct the pupils than to rail against his fellow members of the Academy' – in, it is said, an intensely Irish accent. His criticisms of the establishment would not endear him to Turner, who was passionately loyal to the Academy all his life.

Barry was sacked in 1899 and succeeded by Fuseli, who, as 'both Turk and Jew' (Blake) was capable of some pithy remarks. He is on record as saying of a too persistent student's drawing: 'It is bad; take it into the fields and shoot at it, that's a good boy'. But by November 1899, Turner was already an ARA.

Perhaps the best picture of student life in Turner's day is given in Farington's diary for 31 December 1795. A very bad harvest in that year had driven up the price of bread.

Mr Wilton having mentioned to me that the students in the Plaister Academy continue to behave very rudely; and that they have a practise of throwing the bread, allowed them by the Academy for rubbing out, at each other, so as to waste so much that the Bill for bread sometimes amounts to sixteen shillings a week; and this relation of Mr Wilton being corroborated by Mr Richards (the Secretary), I moved that 'in future no bread be allowed the students'. This was unanimously agreed to. Mr West said independent of every other consideration it would be productive of much good to the students to deprive them of the use of bread; as they would be induced to pay more attention to their outlines; and would learn to draw more correct, when they had not the perpetual resource of rubbing out.

The Plaister Academy:
The Antique School at Old Somerset House by E. F. Burney, 1779. Royal Academy

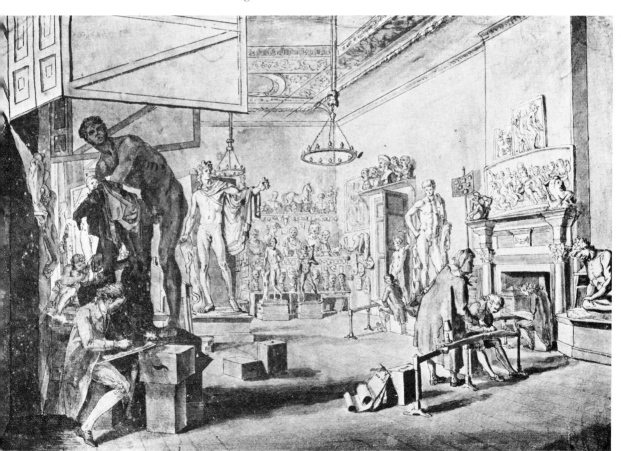

The first·sketchbooks

The earliest sketchbook contains, amongst
copies and perspective exercises, drawings at
Isleworth and, most, near Abingdon. Turner's
'first view of Oxford' is signed and dated 1789—
it would be the summer of his fourteenth
year. A watercolour based on the Oxford view
is also dated 1789, and there are other separate
sheets based on the sketchbook in the Turner
Bequest (III, A–E).

The most attractive drawing in the book is
that of folio 4. Turner has managed to convey
the feeling of an untroubled summer's
morning passed in studying the effects of light
and shade on this pleasant house. The cast
shadows, however, look as if they were added
later with a wash of Indian ink, and they are
inaccurate.

The Bristol and Malmesbury sketchbook (TB VI) dates from two years later – a visit to the Narraways' house at Bristol. John Narraway, a fell-monger and glue maker, was a family friend. His nieces left some account of the young Turner: they seem to have found him good natured, but silent and difficult. He spends a lot of time on the cliffs above the Avon – perhaps his first experience of wild or rugged scenery. Here also are his first ships, accurately detailed as they always would be, however sketchy. His style is now sharp and confident, and he is ambitious with his trees. He has already ceased to make 'tinted drawings'. His modelling is stated directly in washes over the barest pencil support.

He is now well started on his early topographical career. In 1794 his first engraving was published and was followed, in the *Copper Plate Magazine* and the *Itinerant*, and the *Pocket Magazine*, *Ladies Pocket Magazine* and *Pocket Print Magazine* (in fact only two basic series) by nineteen other views before the end of 1795.

above: *View from Cook's Folley, looking up the River Avon* from the 'Bristol and Malmesbury' sketchbook, 1791. TB VI, 24. Detail

right: Turner's first published engraving, 1794. $4\frac{1}{4} \times 6\frac{1}{2}$

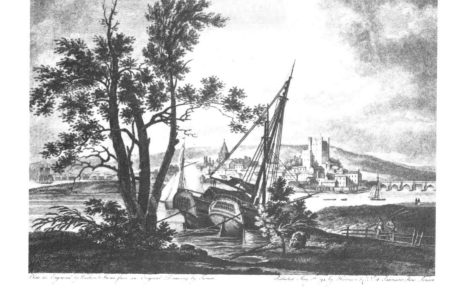

Plate as Engraved by Walker & Turner from an Original Drawing by Turner. Published May 1st 1794 by Harrison & Co. 18 Paternoster Row, London.

ROCHESTER.

Some of the subjects were close to home, but the commission started him off to the Midlands with two small sketchbooks and a collection of Loose pieces of paper. Turner's label on the sketchbook reads *85 Matlock. Northampton First Tour*. An itinerary and notes about the places to visit occupy the first few pages. His tour took him west to Shrewsbury, Llangollen and Wrexham and east to Lincoln and Ely. All the drawings are in pencil, very well organised but giving the impression somewhat of empty outlines, waiting for colour. One, of Lichfield Cathedral, is partly coloured with simple washes which greatly increase the depth and solidity without adding weight – but he got into trouble with one of the towers.

1794

From the *Matlock, Northampton, First Tour* sketchbook.
XIX, 21. 4¼ × 7¼

right: possibly Turner's mother, from the 'Marford Mill' sketchbook

1794(?)
A water mill, probably
Marford Mill, Wrexham.
XX, 19. 6 × 3⅞ ins

The 'Marford Mill' sketchbook is mostly of
slight figures drawn from life; they may be
strolling players. There is a pencil sketch
which may well be of Turner's mother,
nodding by the fireside in a mob cap. The mill
is the only considerable drawing in the book.
The drawing style here makes a complete state-
ment and has lost the outline character of the
Matlock book, perhaps because the artist
was guided by his own interest in the subject,
not leaving himself the option of adding
colour.

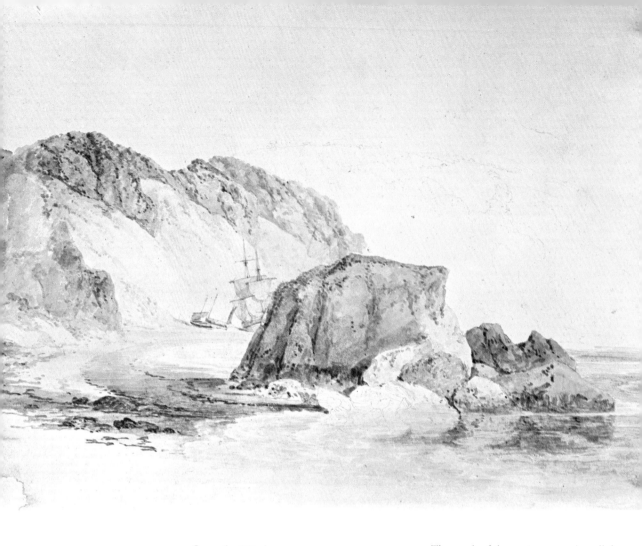

South Wales, 1795

Turner had eight watercolours in the Academy
Exhibition in April, seven of them hanging
as a group – he was now the pet of the
Academy. He had already won a 'Greater Silver
Pallet for Landscape Drawing' awarded by
the Society of Arts. Four of the 1795
drawings are in national collections:

Marford Mill, Wrexham	Cardiff
Transept of Tintern Abbey	Asmolean
Welsh Bridge at Shrewsbury	Whitworth
Lincoln Cathedral	British Museum (LB 19)

The work of the next summer is well docu-
mented in three sketchbooks: *South Wales*,
'Smaller South Wales', *Isle of Wight* (italics for
titles written in by Turner). Finberg reasons
that the Isle of Wight visit was at the end of
the summer, so I have altered the order here.

Turner now has commissions for finished
watercolours as well as for subjects for engrav-
ing—not that he treats them very differently,
but it means that he is building up a clientele
amongst the collectors. A list of *Order'd
drawings* in the South Wales book includes five
of Hampton Court, Hertfordshire for its
owner, Lord Malden (later Essex) and five,
including *St David's Pallace*, for a Mr Lambert.

A rocky bay, from the
South Wales sketchbook.
XXVI, 22. $10\frac{3}{8} \times 8$ ins

22

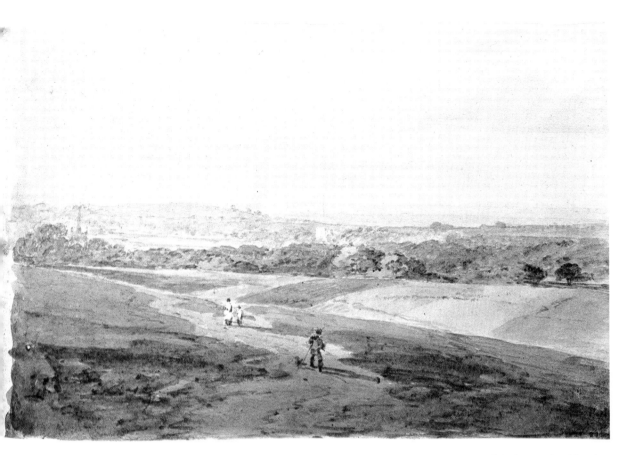

Common and open fields,
small *South Wales* sketchbook.
XXV, 28. 5¼ × 8¼ ins

Sir Richard Colt Hoare, a connoisseur of the Picturesque, also wanted views of Hampton. Against a pair of subjects for Dr Mathews, Hereford, to be done 'the size of the sketch' is a note which suggests that Turner was to have four guineas, altered to £, for the two. Perhaps the other gentlemen paid more: he received 40 guineas for one large watercolour only three years later.

Another list in the Isle of Wight book includes two Salisbury subjects for Colt Hoare and a series for John Landseer, the engraver. These were intended for a publication mainly illustrated by Ibbotson, but all the work was stopped 'owing to a quarrel' (Rawlinson).

The South Wales tour began at Wells, then continued back to Bristol and Newport, Swansea, Neath, Cardiff, and Pembrokeshire; returning via Brecknock and Monmouth. Turner was following an itinerary written out

for him in the front of the larger sketchbook, to which he added his own notes. The farthest point was St David's:

To St David's and back 36 miles (*No Inn* adds Turner) on the right you pass a considerable Tower and remains of Roche Castle. At St Bride's Bay a fine Sea View. St David's Church. The ruins of the Bishop's Palace.

This is a hard-working sketchbook, full of material for his commissions, sometimes in colour. But he has time for details of boats and nets, bridges and houses, and particularly mills. Folio 26, *Carew Castle Mill*, is tremendously professional – and mechanically convincing. It is difficult to reconcile the grace and power of this pencilwork with the primitive quality of the rocky bay, folio 22 – until, perhaps, one looks at the boats. This watercolour may show the influence of Loutherbourg. The atmosphere is slightly

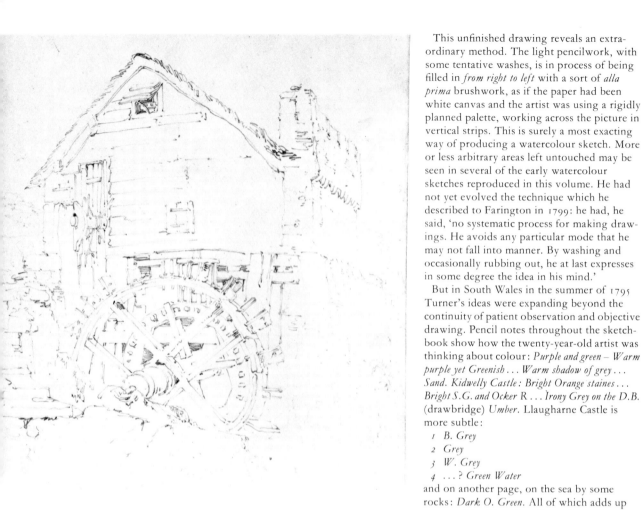

This unfinished drawing reveals an extraordinary method. The light pencilwork, with some tentative washes, is in process of being filled in *from right to left* with a sort of *alla prima* brushwork, as if the paper had been white canvas and the artist was using a rigidly planned palette, working across the picture in vertical strips. This is surely a most exacting way of producing a watercolour sketch. More or less arbitrary areas left untouched may be seen in several of the early watercolour sketches reproduced in this volume. He had not yet evolved the technique which he described to Farington in 1799: he had, he said, 'no systematic process for making drawings. He avoids any particular mode that he may not fall into manner. By washing and occasionally rubbing out, he at last expresses in some degree the idea in his mind.'

But in South Wales in the summer of 1795 Turner's ideas were expanding beyond the continuity of patient observation and objective drawing. Pencil notes throughout the sketchbook show how the twenty-year-old artist was thinking about colour: *Purple and green – Warm purple yet Greenish ... Warm shadow of grey ... Sand. Kidwelly Castle: Bright Orange staines ... Bright S.G. and Ocker R ... Irony Grey on the D.B. (drawbridge) Umber.* Llaugharne Castle is more subtle:

1 B. Grey
2 Grey
3 W. Grey
4 ...? Green Water

and on another page, on the sea by some rocks: *Dark O. Green.* All of which adds up to a considerable palette for a picturesque watercolourist.

In the Smaller South Wales sketchbook we find another numbered scale, perhaps intended to read from distance to foreground – there are no numbers on the drawing. (Finberg detected a 6 at the foot of the page, but it is really a C.) The subject is *Penllyne Castle, Cowbridge*, a distant view.

1 Blue Grey ⎫
2 Grey ⎬ ? the distant hills
3 Grey Grey buff D.G. the castle on its ridge
4 Same with part green a valley in front of th
5 Shadows 3 with W. Green the town and tre
6 More green yet warm a near hillside
Sky Warm Ocker Grey lightly pencilled clou

mysterious and dreamlike. It is a midday dream of the youthful Turner; compelling in spite of its unassimilated local colour and the un-Turnerian, spotty brushwork.

Throughout the book there is a feeling of patient struggle, particularly with the representation of water. Two coloured pages attempt choppy seas, and the results are syrupy. Some waterfalls early in the book (including Melincourt Fall in the Vale of Neath) make similar difficulties for the future master of water and vapour. All seems resolved in a serene, but only half-finished, watercolour of a stone bridge with several arches. This is like a country cousin of the Westminster Bridge (page 52), with some of the same luminosity.

Carew Castle Mill
South Wales sketchbook
XXVI, 26. 8 ins wide

24

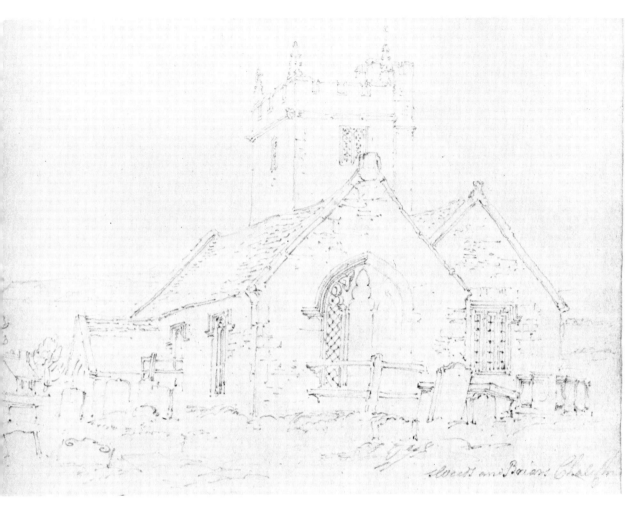

1795

Chale Church, from the
Isle of Wight sketchbook
XXIV, 27. 10⅜ × 8 ins

Apart from *Neath,* engraved for the *Pocket Magazine,* the pencil notes and watercolours in this book are more informal. A pencil Interior of Ewenny Priory was used for a watercolour now at Cardiff. The pleasant eighteenth-century countryside of folio 28 makes an un-ambitious picture, and another page is gently experimental, with atmospheric wiping-out (or blotting with absorbent paper) for a valley full of mist. The book is not nearly half full. Some autumn trees on two pages are not necessarily connected with this Welsh tour, and are separated from the rest by about 40 blank leaves.

Isle of Wight

The Island had recently been discovered by the picturesque artists. A fussy watercolour of Shanklin Chine by Loutherbourg, dated 1794, makes that Chine look grander than it is. Turner may have been guided by either emulation or competitiveness. He had some drawings to do for Landseer (see p. 23) but he may have got the commission because he was going, not the reverse. He went to Salisbury as well, for Colt Hoare.

It is hard to avoid a suggestion of theatrical scenery in the heavily modelled and grandiose barbican of Carisbrooke, and Loutherbourg

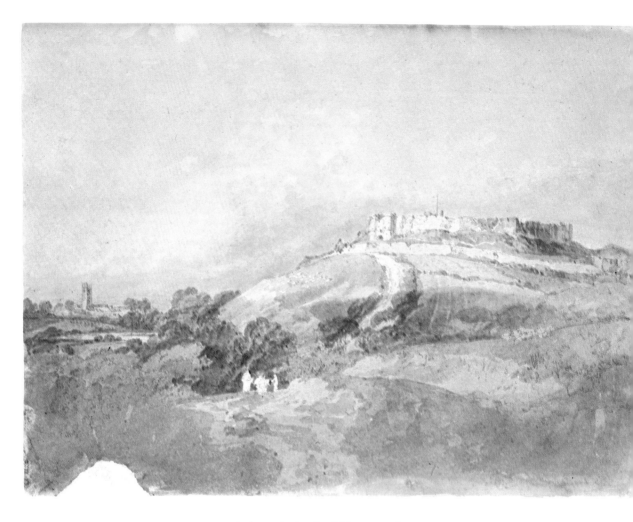

Carisbrooke Castle, from
the *Isle of Wight* sketchbook

appears again in a pale sketch of fishermen off
the Needles, which just might have been the
starting point for Turner's first oil painting,
exhibited in 1796.

In the distant view of Carisbrooke Castle
Turner is very much himself, unaffectedly in
love with a bit of landscape and confident in
his manipulations of light, shade and shadow.
The detail of the middle distance is miniature,
yet does not disturb the breadth and form of
the drawing: an early example of the skill he
was to develop to an almost miraculous rich-
ness in later topographical work.

On the shore he is a little less confident. The
unfinished watercolour of Freshwater Bay

is restrained in colour – a deep indigo sea
and greyish umber for the cliff, including
the grass on top. He surely intended to finish
the drawing, but the complicated winch and
timbers in the foreground would probably
have caused some difficulty against the broad
and effective modelling of the cliff.

Another bay – Totland – in pencil only,
which corresponds closely to the engraving
(Rawlinson 37), has a similar collection of
wooden equipment in the foreground, with
men as well as boats on the shore. Foreground
litter is of course one of Turner's specialities,
but it may have been demanded by the en-
gravers in the first place. They feared the

Freshwater bay.
Isle of Wight sketchbook

monotony of empty tone in their foregrounds,
while definite detail and incident gave them
something to get hold of and helped to throw
back the distance. This is not to deny Turner's
real interest in people and the tools of their
trades, an engaging and indeed essential feature
of his approach to topography.

Several bays are completed, two of them in
watercolour showing Turner again grappling
with the problems of local colour on this
notably coloured coast. All but one have busy
foregrounds. The book is full solid workman-
ship, and, while making many allowances for
youth, one feels that one is handling a con-
siderable work of art, not a mere notebook.

Some wooded inland views in pencil seem
uneventful and look as if, whatever the artist
was thinking or feeling, it did not get into
the drawing. Perhaps here, as often he must
have, he went on drawing after he was tired.
But the lonely little church at Chale (folio 27)
shows how, even when he was preoccupied
with pencilling gothic tracery and other details
(*Weeds and Briars*, he notes, in the foreground)
mood and imagination could prevail. Apart
from the weeds and briars, nothing is under-
stated, and there is not a line too many.

There are very fine architectural pencil draw-
ings of Winchester, particularly the Butter
Cross. The drawing of Winchester Cathedral

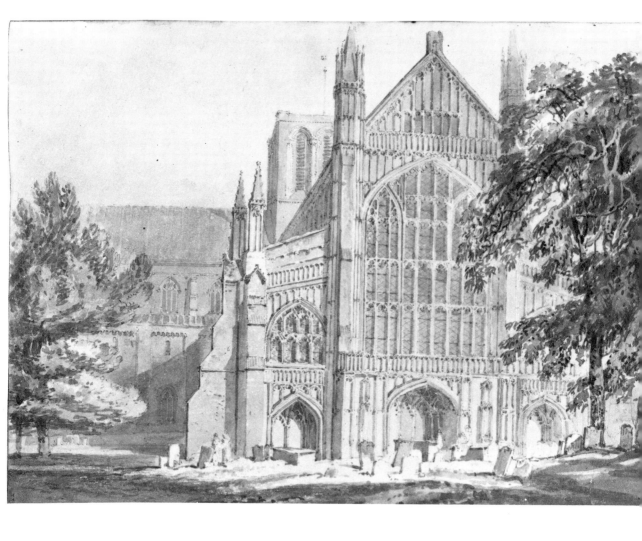

'from the Avenue' is described in the *Inventory* as 'Pencil, with washes of Indian ink and sepia'. The greys may be Indian ink, but the reddish brown which is used, cleverly, to separate parallel from receding planes, is too warm to be called sepia. The total effect is of a beautiful warm light across intricate tracery, the latter faultlessly drawn.

This drawing, and the unfinished *Nunwell and Brading from Bembridge Mill* (see page 30) would be sufficient to establish Turner as a major topographical artist, and at twenty the equal of his teachers. *Bembridge Mill* may have been just another commission, but we see the

sensitive, interested draughtsman at work in the entirely convincing mechanism, and the painter in its excellent relationship with the distant landscape, which itself is sensitively handled. There is nothing slick or superficial here, and while there may be nothing of genius either there *is* an infinite taking of pains and an honest response to visual fact. Does that sound like Turner?

Winchester Cathedral, from the *Isle of Wight* sketchbook

28

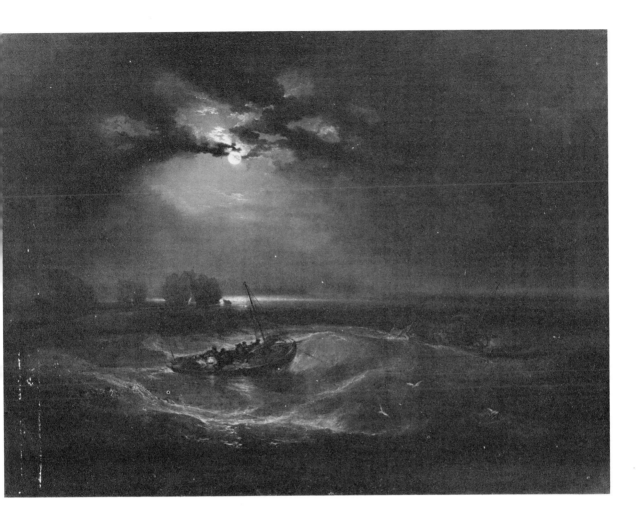

Fishermen at Sea, oil painting
exhibited in 1796.
36 × 48 ins. Tate Gallery

Turner's first exhibited oil painting, *Fisher-men at Sea* — by moonlight, close to the Needles, was in the Academy show in 1796. It is a remarkable performance for a man of 20–21 and shows some of the enormous progress he made in technical mastery about this time. It must have been inspired by actual moonlight, perhaps on a fishing trip from the Isle of Wight, but his choise of subject and his suddenly adept handling of the light on the water point to some painting experience now hidden from us – perhaps some work on transparencies or scenic displays. There were various moonlight painters as precedents, including Wright of

Derby, who became an ARA in 1781 but couldn't spare a painting for his 'deposit' to become an RA.

Of *Fishermen at Sea* the *Critical Guide* said: 'We do not hesitate in affirming, that this is one of the greatest proofs of an original mind in the present pictorial display: the boats are buoyant and swim well, and the undulation of the element is admirably deceiving'. Rothenstein and Butlin (1964) describe the texture as 'rather leathery'.

Another moonlight picture followed in 1797 – *Moonlight, a study at Millbank.* After that this greatest painter of sunrises and sunsets pro-

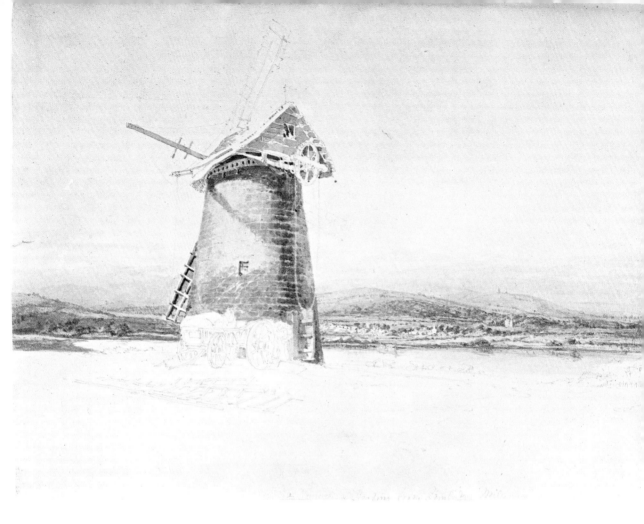

duced no more nocturnes in oil paint. Around
1825 he experimented with a series of dark
mezzotints, including a new version of *Fisher-
men at Sea*. Returning to the Isle of Wight in
1827 he sketched a nocturnal sequence, with
trees and lovers in the grounds of East Cowes
Castle.

The moon appears in the *England and Wales*
series, starting with *Colchester*, engraved in
1827, then becomes part of the rich pictorial
vocabulary of that series, along with rainbows
and storms, rain clouds, twilight, sunsets,
and more storms.

*Nunwell and Brading from
Bembridge Mill. Isle of Wight*
sketchbook, 1795

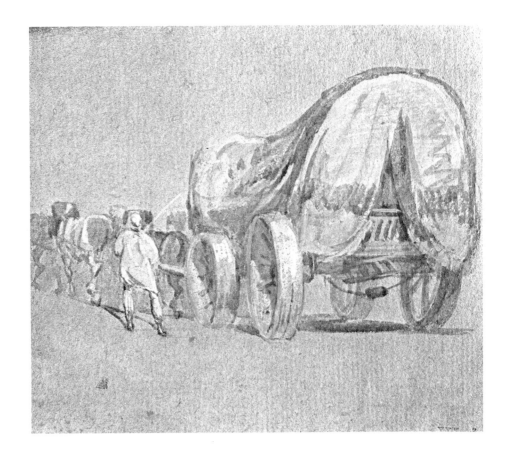

Studies near Brighton, 1796

Waggon and team with waggoner, from the 'Studies near Brighton' sketchbook. XXX, 3. $4\frac{1}{2} \times 5$ ins

There are only a few finished pages in this little book made up of brown, blue and white paper. Finberg notes with distress the small amount of work that can be attributed to this year, suggesting that the drawings are the work of an invalid who had gone to Brighton to recover. He rejects Thornbury's theory that the young artist was in love, and un-happily. Turner aged 21 may have been ill, and in love – we don't know. But surely what he was doing with his time was collecting subjects for paintings, in this little book and its twin, the 'Wilson' sketchbook (p 37). The use of body colour on tinted paper more than hints at his intentions.

It is certainly odd that there is no travelling book with lists of new commissions. His exhibits in the next year were all based on material dating from 1795. Some oil sketches perhaps done at Knockholt, at Wells' cottage, may date from this year. Wilton (1975) suggests that they may well be earlier than the 'c 1800' of the *Inventory*, and the mood and subjects of some of them are in keeping with an interest in moonlight and artificial light. Perhaps, in 1796, he was painting scenery.

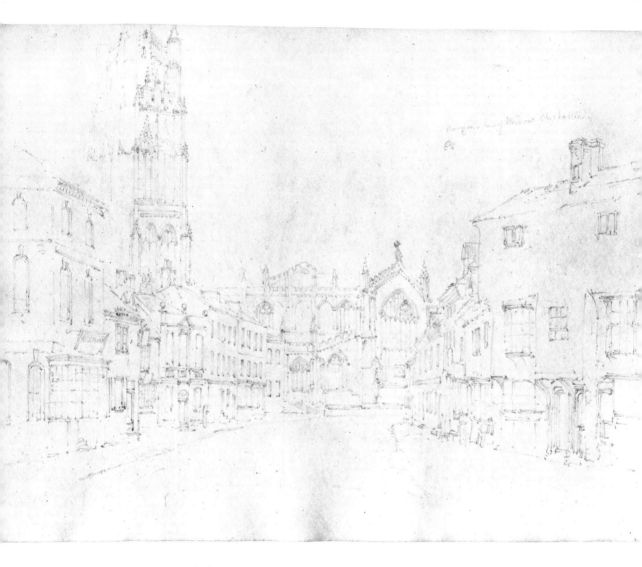

The North-east and the Lakes, 1797

Louth, Lincolnshire, from the 'North of England' sketchbook
XXXIV, 80. 10⅝ × 8¼ ins

Turner had a number of commissions in the North: Derbyshire, Yorkshire and Durham. He was mostly collecting castles and abbeys. His business done he crossed to the Lake District in search of poetic landscape. There were drawings to do also in Ambleside, at Harewood and in York. He took two sketch-books: a largish quarto and a workmanlike 14½ by 10½ inches, the largest so far. He may also have had the small Helmsley book (LIII).

The North-east inspired Turner. Dunstan-borough and Norham were the subjects of paintings exhibited the following year with quotations from Thomson, so we know they were not mere topography. Amongst the care-ful pencilwork of the 'North of England' sketchbook are lyrical scenes for which he resorts to pale, luminous washes of colour. The page with a small boat setting out at

Berwick-on-Tweed, early morning, from the 'North of England' sketchbook. The warm colour is the result of exposure in a frame when the drawing was exhibited under Ruskin's direction

sunrise (it must be sunrise because we are looking eastward) contains elements of the 'real' Turner: the lonely fishing boat; the diffused light, its source within the picture; even the lines of the composition pivoted on an off-centre axis are a favourite device of later years. The warm colour is due to exposure in Victorian times.

There are many germinal subjects which admirers of his *Liber Studiorum, Richmondshire* and *England and Wales* will recognise: Kirk-stall Crypt ('sound preaching at last here . . . concerning fate and life', wrote Ruskin); St Agatha's, Easby; Egglestone Abbey; Tyne-mouth on its headland; Alnwick by moonlight – but only in pencil here; Dunstanborough, Boston and Stanford; and Norham Castle at sunrise, which remained a potent image through many different versions to that ultimate chromatic distillation of about 1840.

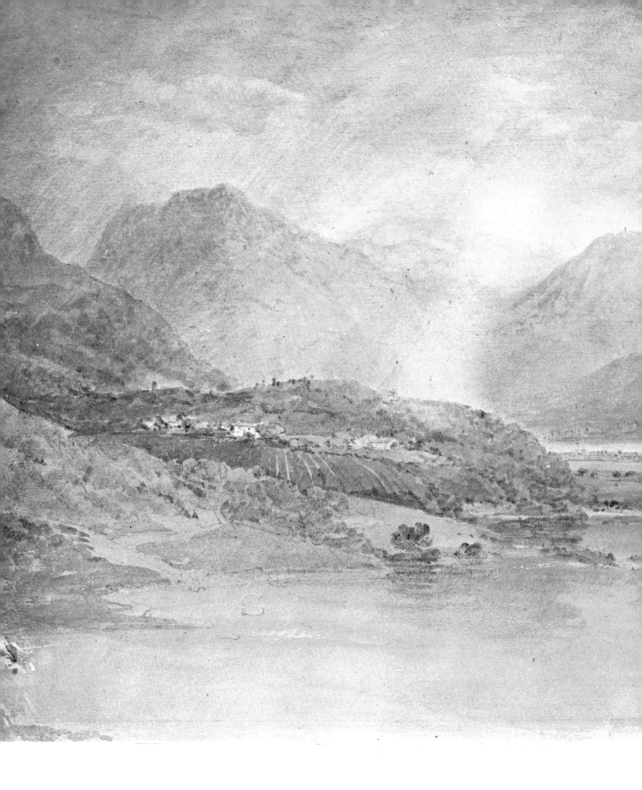

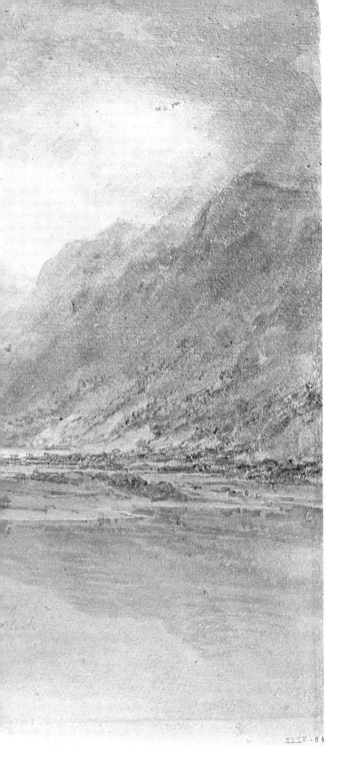

The larger sketchbook, called 'Tweed and Lakes', contains the important sketch for *Buttermere Lake with part of Cromackwater, Cumberland, a shower*, the oil painting exhibited in 1798. A quotation from Thomson in the catalogue had the 'downward sun...effulgent', and 'the grand ethereal bow' which Turner added to the painting, the sketch having only the shower of the title. Another water-colour page has a similar split-level effect of two lakes separated by moraine rock: *Grasmere, Rydal Water* is Turner's label.

Buttermere Lake, with Part of Cromackwater, Cumberland, a Shower. Oil painting. 36 × 48 ins, exhibited in 1798. Tate Gallery

left: the sketch from the 'Tweed and Lakes' sketchbook, 1797 XXXV, 84. 14½ × 10½ ins

He investigated the Lake District very thoroughly, from *Keswick* to *Lower end of Winder, Old Man* and Coniston. He drew *Ferness Abbey*, then went to Lancaster, then York, with only a superficial look at Bolton Abbey. In York he filled several of the large pages with impressive Gothic detail, exercising his now impeccable perspective by choosing unusual viewpoints. The faint outlines of *Ouse Bridge*, York reveal a splendid composition, very different from Girtin's views of the bridge, which survive in finished watercolour.

35

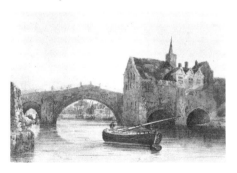

Ouse Bridge, York, from the
'Tweed and Lakes' sketchbook.

right: watercolour by Girtin,
probably 1796

Perhaps Turner makes the Ouse into a sort of
Grand Canal, prophetically, while Girtin's is
always a slow Yorkshire river.

The two young artists drew so many of the
same subjects at about the same time that it
is not surprising that they were once believed
to have travelled together. Their paths seem
to cross in Yorkshire and Durham, but it
appears that Girtin's drawing in the area was
done in 1796, while in 1797 he was sketching
in the West Country and starting his panorama
of London.

The 'Wilson' sketchbook

The chronology of the catalogue* takes us
from one of the largest to the smallest sketch-
book – reproduced here nearly full size. It
looks as if it was in Turner's pocket for a
long time, and the contents bear this out. It is
undateable really, except for some notes of
bonds (?) *Dec* and *Nov 97*. It is a remarkable
document. Turner's label reads *84. Studies for
Pictures. Copies of Wilson*. The Wilson copies
are in the minority. It is a collection of minia-
tures in watercolour, chalk and body colour.
Some are quite complete, such as the several
church interiors and a distant view of St Pauls,
both of which subjects are close to similar
ones in the *Liber Studiorum*, begun ten years

* TB XXXVI is a collection of miscellaneous 'North of
England' drawings, including some very large water-
colours – about 22 × 30 inches.

later. The snow scene is also a type of land-
scape with figures more to be associated with
the *Liber* period. This, and the common with
a windmill on folios 62 and 63, and several sea
pieces, do not appear again, so far as I know,
in Turner's work. Various more sketchy land-
scapes, not usually entirely satisfactory, are
yet reminiscent of the Petworth Park scenes
of 30 years later.

All the paper is grey with a brown wash. Its
darkness, tattered edges and worn appearance,
its rich colours and great variety of unexpected
scenes; all combine into an object of extra-
ordinary presence and individuality. Nearly
every page is coloured, but the colouring is
not adventurous even by Turner's standards
of the time: the rich browns and purples
relieved by glowing ochres which Burke des-
cribed as the 'sublime' colours, 'sad and
fuscous' (see Wilton, 1975, page 23). His
palette seems restricted to a few chalky opaque
colours, some applied wet, some dry. The

TB XXXVII, 'small pocket book,
bound in green leather, with one
brass clasp' . . . containing 64
leaves of grey paper washed with
brown.
Size of page, $4\frac{1}{2} \times 3\frac{5}{8}$

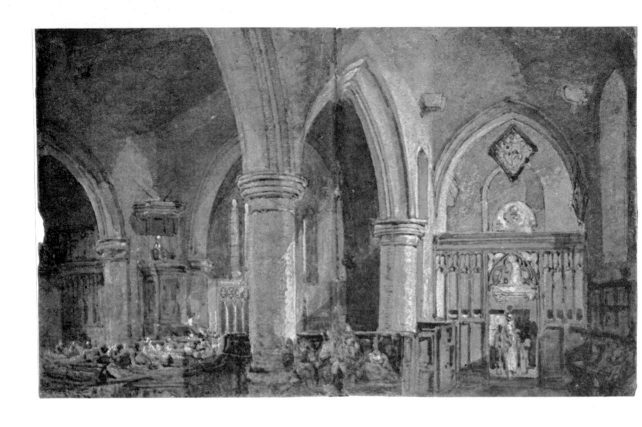

existence of a crude monochrome version of
one page, placed by Finberg amongst the 'draw-
ing copies' for or by students (XXXI), at least
puts in one's mind the idea that many of the
'studies for pictures' in this sketchbook had a
teaching purpose. Turner is known to have
had several drawing pupils, and his method
was, as Farington mentions, to make them a
picture to copy: 'His last practice was to make
a drawing in the presence of his pupil and
leave it for him to imitate' (30 Oct 1799). Is
the Wilson book a pedagogical sketchbook?
If it is, only in part, the link is even clearer
with *Liber Studiorum*, which was certainly in-
tended to educate. And this theory would help
to explain the rather elementary nature of
some of the compositions (see p 58, *Turner's
Early Sketchbooks*).

Pages from the 'Wilson' sketch-
book above, 36, 37, Interior of a
church opposite; 68, 69, Snow
scene, and 56, 57, Distant view
of London

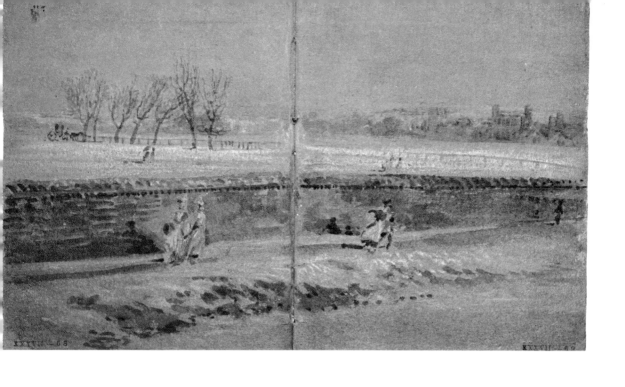

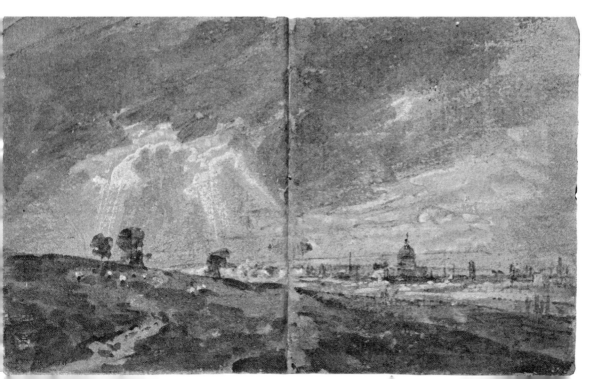

Some coastal scenes and the fishing boats (Deal luggers?) of folios 106, 107, seem to connect the book with the S.E. coast, and therefore possibly with the Studies near Brighton which Finberg placed in the previous year. The sea pieces seem too close to Turner's personal poetry to be teaching exercises: but there is in the British Museum a larger gouache of fishing boats, which, according to an inscription on the reverse, was done for a student. Some vigorously brushed, cloudy landscapes, also, have an air of spontaneous reaction to things seen.

'Studies for Pictures' in fact covers a fair variety of material. If the Petworth drawings of 1827–30 had been done in a small sketch-book, as they might have been, would Turner have given them the same title?

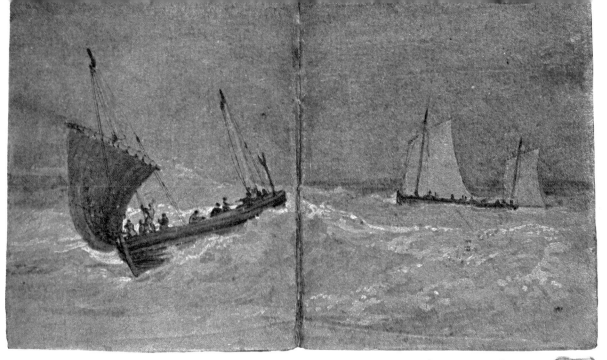

opposite: 114, Sunrise or sunset
at sea, and 62, 63, Pathway across
a common

on this page: 106, 107, South Coast
Luggers coming in to the beach,
and the first or last page of the
'Wilson' sketchbook, a sea piece

Welsh Sketchbooks, 1798–9

1798(?)

Malmesbury Cross, from the *Hereford Court* sketchbook XXXVIII, 6. 13 × 9 ins

opposite: folio 81 contains this unfinished watercolour of the Junction of the Severn and the Wye; below is Turner's etching of the subject, 1811, for the *Liber Studiorum*

On his north-eastern tour of 1797 Turner had gathered scenes and impressions which would provide information and inspiration for many later works. Only in the Lakes had he allowed himself to concentrate on subjects for his more imaginative oil paintings. Now, in Wales, we find him much more preoccupied with his painting. Though he still has commissions to draw for, he seems much more concerned with ideas as he rides into the mountains from Bristol. The Narraways gave him a horse, and lent him a saddle, bridle and cloak – 'these he never returned', wrote Narraway's niece in 1860. 'My uncle used to exclaim what an ungrateful little scoundrel, and with this

incident the intercourse between Turner and our family terminated.'

The '*Hereford Court*' title, Turner's abbreviation of Hampton Court, Hereford, refers to 1795. Some of the work in this sketchbook belongs to that year, but he may have had some of the drawings of Hampton and Malmesbury to finish for Colt Hoare.

With, I believe, the idea in his mind which he later embodied in *Dolbadarn Castle* (1800) he seems to have decided to collect castles in Wales. Dolbadarn was the prison of an anguished soul, but he saw other castles in a different light. In the titles of *Kilgarren Castle on the Twywey, Hazy Sunrise, previous to a sultry day* and *Harlech Castle, from Twywyn Ferry, Summer's Evening Twilight,* oil paintings which he exhibited in the following year, we see his preoccupation with particular effects of

weather which he associates with particular places, often so forcefully that they are welded into a single image – true to the subjective mind. Do we think of any place which has a meaning for us without setting it in a particular kind of weather and time of day – though we may have known that place in every kind of weather and at all times of day? This idea is behind all Turner's greatest topographical work. It was to this sketchbook that he returned, over thirty years later, for at least three of the subjects of his *England and Wales*.

He worked hard on these subjects, and the sketchbooks show his failures more than the results. But his eye for the effects of weather is keen as, on his first day out of Bristol, he records a very particular cloudy sky over the Severn – a Welsh sky, though we are looking from Wales into England. This view he turned

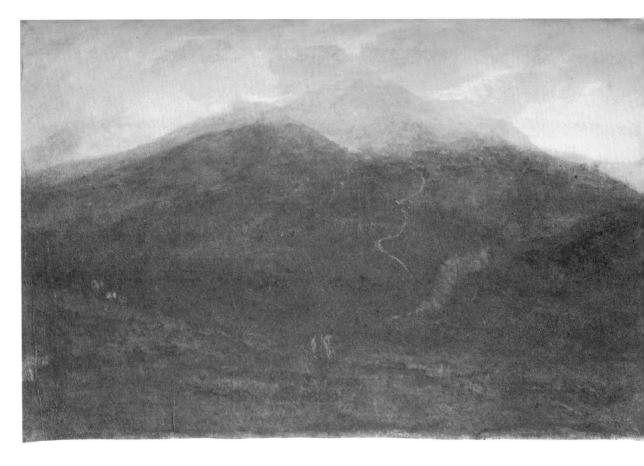

Welsh mountain landscapes from
the *Hereford Court* sketchbook:
folio 83 and, opposite, 98

into a more generalised Claudian plate in the *Liber Studiorum*—without the interesting clouds.

He worked assiduously too, in collecting his castles: besides Dolbadarn, Kilgarren and Harlech, already mentioned, he drew, from several viewpoints and often in watercolour, Caernarvon, Chepstow, Carreg Cennen, Conway, Dinas Bran, Ludlow and Montgomery. I wish he had climbed the Glyder to see that other Welsh castle, of rock, Castell-y-Gwynt. He drew *Snowdon from Quathlynn* (Cwellyn) and from other viewpoints, and 'Bedgellert by Moonlight'.

It sounds like a wonderful picture-book of Wales, but in fact it is a working-out book. The watercolours are usually solid and over-worked (he was making studies for oil paintings) and there are some muddy compositions that are so dull and prosaic as to suggest the

alien hand of an inept pupil rather than Turner's own. But they are Turner's work; almost certainly, on stylistic evidence, dating from an earlier unrecorded visit to Wales. These were the drawings that Hoppner saw, I am sure, that 'tended too much to the brown'. The foregrounds are all obsessively so.

The book is difficult to follow, because many pages in colour were removed by Ruskin for exhibition (as 'Yorkshire Moorland', 'Skiddaw' etc). Finberg rescued these and put them in the end of the book. Colour has faded from these exhibited pages. The Lake of folio 98, for instance, is a discordant ferrous brown presumably lacking a fugitive blue pigment.

Turner made several notes of the names and addresses of buyers, and some prices: ten guineas for watercolours. On a drawing of Conway Castle appear the following names:

Pope

Wm Blake [another Blake, a pupil]

Mr Leader 4 F 8 long 3 F 6 wide 70

The oil painting of Conway Castle from the Leader Collection belongs to the Duke of Westminster. Finberg dates it 'about 1802'.

In September 1798 Farington notes that 'William Turner...has been in South and North Wales this summer – alone and on horseback – out 7 weeks. Much rain but better effects [associated with it]. One clear day and Snowdon appeared green and unpicturesque to the top'. Turner had probably used the term 'unpicturesque' only to make himself understood to Farington; but the association of green with the unpicturesque is interesting.

One sketch reproduced here will show that Turner was concerned with much more than the merely picturesque: folio 83. This dark mountain with its gleaming path or rivulet is a symbolic, not a chorographic mound. Though receptive to all the moods of the weather and the hour, he is now aware of his more purely romantic themes as a painter – soon to be revealed, but here and in other sketchbooks struggling through several stages of modification from the initial conception.

In the dark composition here the slow movements of smoke and the zig-zag path (or stream) suggest a climbing theme. A snatch of verse from the 'Swans' sketchbook begun in this same year, suggests the clue:

Oh how weakly then the weary traveller
Threads the maze towards the mountain top.

The understanding of Turner and his *Fallacies of Hope* begins here, I think, on his hopeful journey amongst the dark hills of Wales.

The North Wales Sketchbook

With great ideas in his mind he was still conscious that he had much to learn. This journey, collecting castles and seeking visions of epic grandeur – but being seduced by interesting 'effects' – was really a pilgrimage, as he wrote in 1847, 'in search of Richard Wilson's birthplace'.

Wilson was born, in 1714, at Penegoes in the Dovey Valley, and the *North Wales* sketchbook begins at page 1 with *Penegos*, the place being marked with a cross. Turner did not have to look very hard for the birthplace. His search was more for Wilson's spiritual home, and it took him to *Pool on the Summit of Cader Idris*, the scene of a Wilson painting, as we see from a page in the *Hereford Court* book. A brown watercolour beginning is heavily spotted with rain – Wales is like that – but a finished version has a rather less evocative effect.

The North Wales sketchbook, considerably smaller than the previous one, is mostly monochrome. It covers some of the same subjects, but mostly in pencil, or pencil and white chalk. Some rough pinkish paper is bound in (leaves 44–86) but the white chalk is only used on the white paper, where it doesn't show up. Folio 66a, the shore with mountains, reproduced here, is on the pink section. It is a very fresh, modern-looking drawing with much dry brushwork on the rough paper – no pencil-work.

In the waterfall, folio 9, and on three or four adjacent pages Turner has found it necessary to indicate some patches of tone in pencil – these patches of 'shading' are a new departure for him. (Some shading is used in *Carew Castle Mill* – see p 24 – but only as a flat tone).

Many pages of fluid, unconsidered pencil-work of wooded valleys again, as in the Isle of Wight sketchbook, impress more by their

1798(?)

Monochrome wash drawing from the *North Wales* sketchbook XXXIX, 66a. $10\frac{1}{2} \times 6\frac{5}{8}$ ins

Waterfall, probably Cynfael Falls near Ffestiniog. *North Wales* sketchbook

quantity and featurelessness than by anything vivid. This extraordinary habit of Turner's, of covering page after page with swarming lines has been described as a 'nervous tick' (Andrew Wilton).

Among the pencil subjects are Harlech and Criccieth Castles, and three watercolours at the back (front?) of the book include the sketch for the oil, *Harlech Castle from Twywyn Ferry, Summer's Evening twilight.*

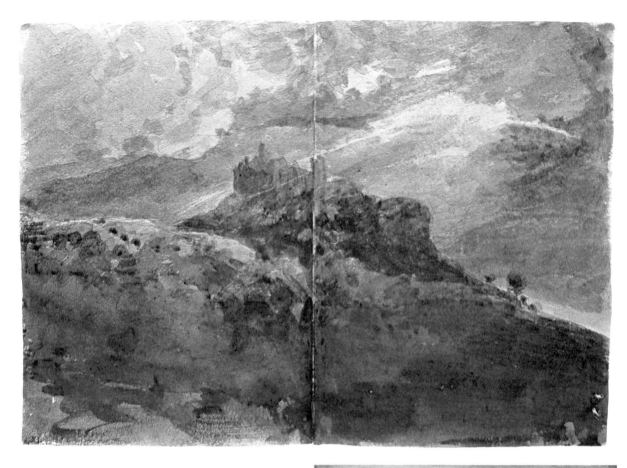

1798(?)
Ruined Castle (Caer Cennen?)
from the *Dinevor Castle*
sketchbook
XL, 38. $5\frac{1}{4} \times 3\frac{7}{8}$ ins

right: oil painting called
'Mountain Scene' and dated 1798.
17×21 ins. Tate Gallery

48

XL - 60 a

XL - 51

Dynefwr

Dinevor Castle is Turner's caption to a sketch
on the inside cover of this small sketchbook
which accompanied him to Wiltshire and
South Wales, and, probably in 1799, to Kent.

Dynefwr, Dryslwyn and Carreg Cennen are
ancient Welsh Castles close together near
Llandeilo – at Dynefwr there is also a much
newer castle. The one watercolour in this little
notebook appears to be of Carreg (or 'Caer')
Cennen, a most impressively situated pile,
often painted.

Folio 60a may be a design for the *Army of the
Medes destroyed by a whirlwind*, a picture which
has not been heard of since it was exhibited
in 1801 and drew great praise from Benjamin
West: 'It is what Rembrandt thought of but
could not do.' The *Star* said: 'To save trouble
the painter seems to have buried his whole
army in the sand of the desert with a single
flourish of his brush.'

Design, perhaps for a lost picture,
from *Dinevor Castle* sketchbook

49

There are some architectural details of
Malmesbury and '*Laycock*', a pleasantly inti-
mate drawing of Laycock Abbey, Wiltshire,
and, with a touch of wash, a fleeting image of
Saltwood Castle, Kent – so identified by Lord
Clark, who lives there.

Laycock Abbey, Wiltshire:
Dinevor Castle sketchbook.
Folios 85a, 86

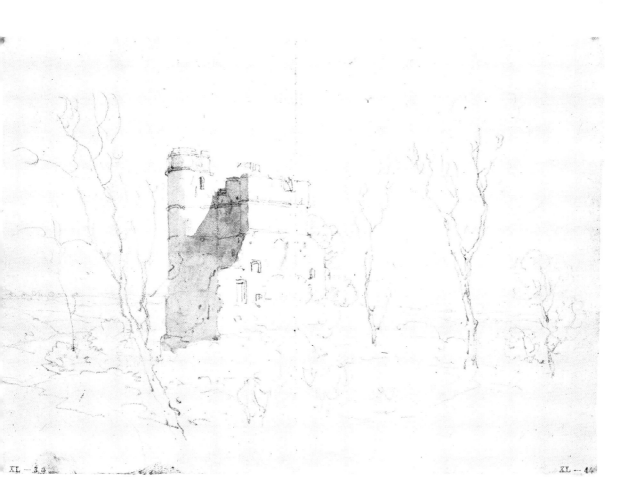

XL — 3a

XL — 4

Part of Saltwood Castle,
Kent from the *Dinevor
Castle* sketchbook, 3a 4.

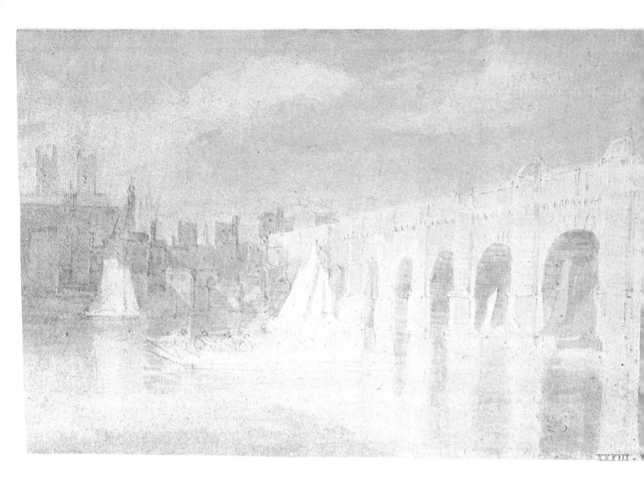

A pause

Old Westminster Bridge, watercolour on heavy, absorbent paper, actual size. XXXIII, W. about 1796.

The previous drawing, done in Kent, suggests a possible pause in the travails of Wales. The beautiful watercolour of Westminster Bridge – this is the old unfamiliar Westminster without Big Ben – was exhibited, so we are told by Rawlinson and Finberg, in 1822. Sure enough, no 271 in Cooke's Exhibition of Drawings at 9 Soho Square, 1822, is titled *Westminster Bridge from the Surrey Side, looking towards Westminster. An early drawing of the Artist.* It hung between a De Wint and a Stothard and was one of 24 of Turner's drawings amongst a glittering array of contemporaries and old masters.

But I think it most unlikely that Turner would allow an unfinished sketch to be shown. A similar drawing with Thames barges was supplied by Turner to the engraver of the *Copper Plate Magazine* published in August, 1797. Rawlinson says that this drawing, which belonged to John Britton at the time of Cooke's exhibition, must have been bought

Cardinal Morton's Tomb in
Canterbury Cathedral, catalogued
as 'The Crypt, Hereford'
XXVI, 72. 10⅜ × 8 ins

back by Turner, and that it was 'much faded'. Finberg identifies it as the one reproduced here, but I think this one is later than 1797, and it is not much faded, only judiciously incomplete.

The equally luminous study of Cardinal Morton's Tomb in Canterbury Cathedral is from the 1795 *South Wales* sketchbook – amongst some pages which had been cut out and exhibited in Ruskin's time. According to an account of Rigaud's son Stephen in 1855, Turner was in Kent in April 1798, and he was there again in the autumn of 1799, as reported by Farington. These are more likely dates for the drawing, which is described in the *Inventory* as 'The Crypt, Hereford Cathedral' – but Finberg corrected this, by implication, in 1939.

Cyfarthfa

Turner Bequest no 41 is: 'Dismembered leaves of large sketchbook. Covers missing. Nothing to indicate the original order of pages'. It is dated 1798, this being inferred from the presence of four drawings of Cyfarthfa ironworks, a commission noted in the *Hereford Court* sketchbook.

4 Drawings of the Iron Works of Rich^d Crawshay Esq at Cyfaithfa, near Merthyr Tidvil – 18

miles from Cardiff – 16 from Brecon
10/9½ by 13 inches — 5G. each
2 Mr Blackshaw Carfilly Castle

But then there is nothing to prove that the *Hereford Court* book was completed or partly completed in 1798.

Below is one of the pencil sketches of the iron works – an industrial landscape of the late eighteenth century, and an unusually objective one. The pencilwork for Caerphilly Castle is duly executed on another four pages

1798(?)

Cyfarthfa Ironworks: part of a page from the large 'Cyfarthfa' sketchbook, XLI, folio 1.
18 × 11½ ins

Other castles appear: Powys, Cardiff, Flint and others not identified. The book is full of interesting things, most, I believe, later than 1798. The atmosphere is relaxed, particularly in several pages of ships being manoevered by men in rowing boats down a steeply banked river which Finberg identifies as the Usk. Black and brown washes are used for these, the brush doing most of the drawing. Brown and blue wash is skilfully deployed for some impressive river scenes without navigation. These were exhibited until 1905 when it was found that the blue had disappeared, only remaining where the mount had covered it. Perhaps some method of photography outside the visual spectrum could recover this faded blue?

The companion small book which Turner labelled *South Wales* but Finberg called 'Swans', is next in the catalogue. The more important work in it however is not connected with Wales but with Fonthill Abbey and I have placed it in that context.

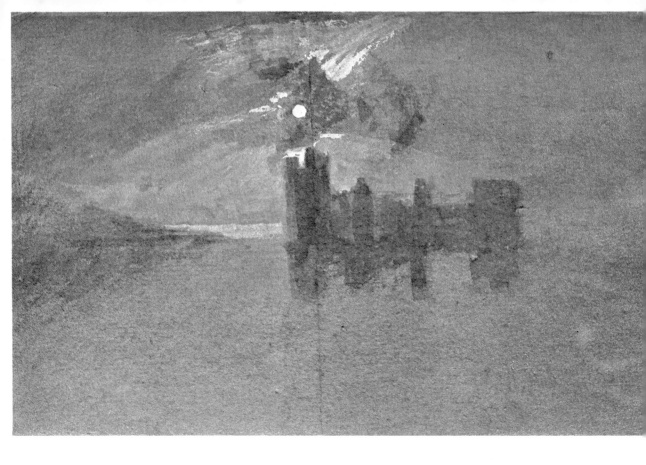

'Academical' – and Romantic

A great deal can happen in two years and Turner seems to have been extremely active in several directions during 1798 and 1799. Farington mentions him frequently. Turner was now anxious to be elected an ARA, and he must have spent all his spare time canvassing, though he could not go to the lengths of a rival, Arthur William Devis, who gave a dinner for some members, and sent his carriage for them (Farington, October 1798). Nollekins, Bourgeois, Sawrey Gilpin, Stothard and others had promised Turner their vote. Lawrence was certainly on his side, and as he had been elected at 22 he could not object to Turner's youth. Turner could probably rely on Hoppner and Farington. In the event he polled twelve votes in the second ballot. But the list of candidates was formidable –

1798(?)

above and right: two of five studies of Caernarvon Castle in the brown paper *Academical* sketchbook.
XLIII, 42a and 43a. 8½ × 5½ ins

24 men, including Francis Towne (then about 38), James Ward, Martin Shee and Thomas Malton. Poor Malton, who had taught all he knew to Turner, didn't stand a chance – he only drew what others had designed.

Even Turner said he could submit patiently if Rossi was preferred (who was Rossi?) but he couldn't stand Devis (a topographical artist, the son of the famous Arthur Devis). Shee and Rossi, the favourites, were elected, with Turner an honourable failure – but he won in the following year's Academy stakes.

Caernarvon Castle continued to occupy his mind, as the sketchbooks bear witness. Water-colours of the subject were exhibited in two consecutive years, 1799 and 1800. He probably planned a major oil painting, judging from the number and variety of studies and the use of a dark ground.

The two pages above, on brown paper

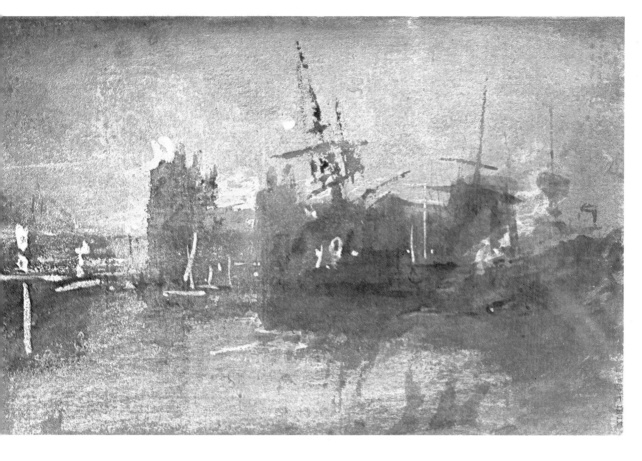

prepared with a wash of (removable) blue, are from a sequence of five in the sketchbook labelled *Academical*. This was Turner's name for it, referring probably to some primitive coloured life drawings which must date from his first months in the life class (1792?); and not to his struggles in the Academy elections. The book also contains some overworked and immature landscapes, early failures which, it seems, he was content to live with.

Besides the rather frenzied series of blue and white studies on the brown paper there is a yellowish gouach-and-ink version (reproduced in Gage). This and the similar-sized oil sketch in the Tate Gallery conform approximately to the outlines of the pencil sketch, overleaf, which almost certainly belongs to 1799. There is material for an interesting thesis on Turner's Caernarvon, apparently so much greater in the planning than in the results (see page 63, here, and TB XLIV H, I and Y). The first watercolour, of 1799, is in a private collection, this quotation attached:

> 'Now rose
> Sweet Evening, solemn hour, the sun declin'd
> Hung golden o'er this nether firmament,
> Whose broad cerulean mirror, calmly bright,
> Gave back his dreamy visage to the sky
> With splendour undiminish'd.' (Mallet)

The second *Caernarvon Castle*, exhibited in 1800, though still set in a 'sweet' evening light, looks to 'Mona's distant hills' – 'drench'd in blood'. A harpist and a Welsh choir of 'Arvon's Swains' join in a 'song of pity'. Turner had found Gray's poem *The Bard,* which celebrates the legend of Edward I's extermination of the Welsh Bards. The lines in the catalogue were his own, and with

those composed for Dolbadarn Castle, are the first he ever published.

His break-through from topography, via the picturesque and the poetry of natural phenomena, to Romantic Landscape, was made in this way. He had sought some kind of literary/historical background for his chosen subject and had striven, through the processes of design, to express this in his work. He was determined to put his landscape art on the highest level of taste, which meant the time including 'History'. And he had been forced to introduce figures into his composition – not merely as decorative 'staffage'. The people in Turner's work always mean something.

1799

Pencil drawing of Caernarvon from the *Lancashire and North Wales* sketchbook
XLV, 26a. 13 × 9 ins

Lancashire and North Wales

Turner got 40 guineas for his first Caernarvon Watercolour – much more than he would have asked. The second one, with its Bardic theme, did not sell.

In July 1799 he had 'sixty drawings now bespoke by different persons'. These include twenty drawings of Salisbury for Colt Hoare (who clearly knew a good draughtsman when he saw one). He had ten drawings in hand for the Oxford Almanacs; one, *Christchurch from the Meadows* was already done and engraved in 1799. Dr Whitaker, vicar of Whalley, near Blackburn, a noted antiquary and tree-planter, commissioned him to provide some of the illustrations to his large *History of the Parish of Whalley*.

Turner went to Lancashire and worked hard as usual. His careful *Seals of Whalley Abbey* in

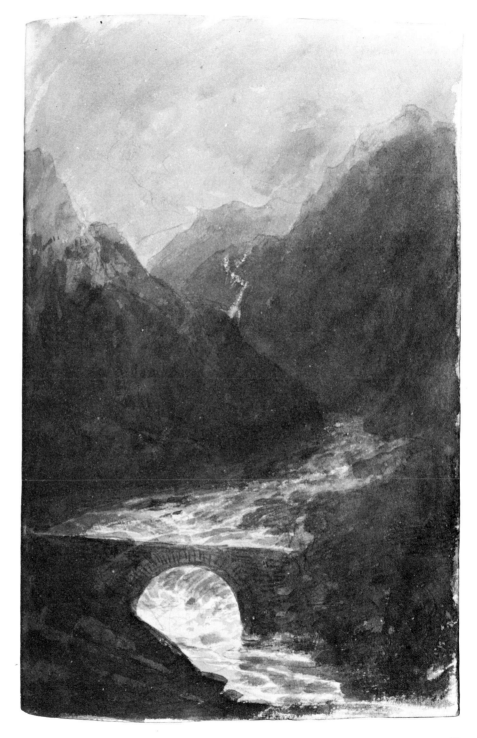

Wash drawing, folio 7a
from the *Lancashire and North
Wales* book

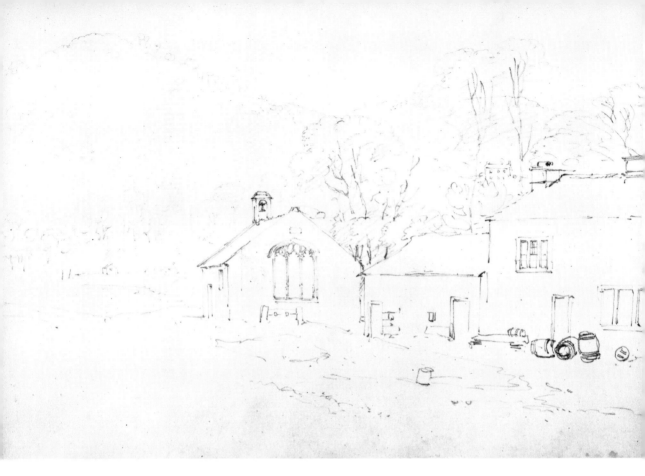

the Fitzwilliam Museum show how completely
he could give himself to the work in hand.
Some of his drawings were not used, a local
artist being preferred as in the case of the
illustration of Whitewell, for which there are
three serene sketches in the *Lancashire and
North Wales* book.

Finberg has him returning, hurriedly, via
North Wales to snatch another look at
Caernarvon; but he may have gone there first,
or not at all in this year. The wild torrent,
in monochrome wash (p 59), makes a
startling contrast with the steady outlines
of the castle—but both are true to Wales,
as are the tenderly observed details of
Whitewell to Lancashire.

Whitewell, on the River Hodder,
Lancashire—catalogued as a
Welsh chapel: *Lancashire and
North Wales* sketchbook.
XLV, 27

List of Cloathes

3	Coats
4	Waistcoats – White
5	Breeches
4	Underwaistcoats
6	Cotton stockings
8	Silk stockings Black
3	Cravats
3	Pocket handkerchief
3	Boots
3	Shoes
1	Colour'd Waistcoat
6	Shirts
2	Welch stockings
1	White Silk Stockings
1	Silk Handkerchief
1	Great coat
1	Overalls
1	Black waistcoat

Dolbadarn

A small notebook gains the title 'Dolbadarn' from two pages which include the castle but have no particular relevance to the oil painting—they more resemble a large watercolour, LXX–X (reproduced in Wilton, 1975). From the great variety of styles and subjects amongst these 240 pages we may infer that the little book was in Turner's pocket at all times during his Welsh journeys of 1788–9. It is a difficult collection to summarise.

The tonal pencilwork, typified by folios 37 and 54, is new at this stage of Turner's work. The two compositions in line and wash, overleaf, are hard to ignore because so attractive. There are other pictorial designs, and some copies, in watercolour and pen. The main part of the contents is North Welsh scenery, sometimes obviously from direct observation, with place names written in, and sometimes apparently noted down from other sources. There are cloud studies in pencil – one is labelled *Rain approaching after sunrise* –

and mountain landscapes with numbers all over them, presumably representing a tonal scale. Studies of plants – not common in Turner's sketching – turn up here and there, never very detailed; some life drawings, some figure groups, and one harpist (on folio 1). Turner's *List of Cloathes* at one end of the book is balanced by lists of French verbs and pronouns at the other, while another list (on folio 1a), after the harpist, runs through a poetic gamut of weather effects:

Twylight	*Sunney*
Clear	*Sunrise*
D. Rain ? bow	*Bright*
Crimson'd	*Rain?*
Dewy	*Hazey*
Cloudy	*Dawn?*
Midday	*After Rain*
Rain?	*Fog*
Showery	*Gathering . . .?*
Squall	*Breaking up*
Storm	*Tranquil*

Mountains and Clouds numbered according to a tonal scale, and below, Llanberis Lake and Dolbadarn Castle. 'Dolbadarn' sketchbook.
XLVI, 19a and 44. Actual size

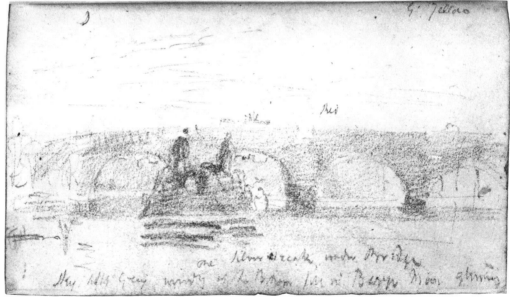

G. Yellow

Pencil study of Caernarvon Castle,
54; a barge and a bridge with
Red cloud and the moon.

One Silver Streak under Bridge
Sky Light Grey in the Bottom till nr. Barge. Moon glim'ring

Folio 37. From the 'Dolbadarn'
sketchbook

Top: Snowdon range with
rainbow: pen and brown wash,
blotted out. 'Dolbadarn'
sketchbook, 74a.

below: Sea piece: watercolour
with scraping out. 'Dolbadarn'
118a.

or Diploma work, on being elected an Academician. The painting still hangs in the Royal Academy. Nothing of the brilliant yellow and cerulean blue of the pastels was retained in the oil.

As I now believe, the pastels were not drawn in the shadow of Dolbadarn crag in the twilight of a summer evening, but in the studio. Still they record an experience in that place and at the same time contain the first hint of Turner's brilliant use of pure colour.

The verse in the catalogue, as for Caernarvon in the same year, was Turner's own. Owen the Red was imprisoned at Dolbadarn for 23 years by his brother, Llywellyn ap Iorwerth, says the *Shell Guide to Wales.*

Turner's castles, if they do not sit in the background as witnesses of a benign feudalism, are monuments to human suffering: all his sunsets and sunrises are symbolic of the untrammelled mind of man.

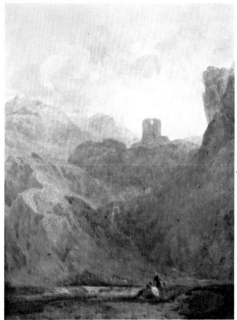

Study for *Dolbadarn Castle. Studies for Pictures,* LXIX, 104: right: *Dolbadarn Castle,* oil, 48 × 36 ins. Royal Academy, London

A startling series of pastels on blue paper, in a book of 'Studies for Pictures' (see also page 84,) records Turner's evolving of his Dolbadarn picture, exhibited in 1800 and presented to the Academy as his 'Deposit'

How awful is the silence of the waste,
Where nature lifts her mountains to the sky.
Majestic solitude, behold the tower
Where hopeless Owen, long imprison'd, pin'd,
And wrung his hands for liberty, in vain.

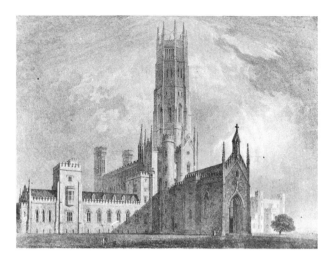

Fonthill, love, and madness

Beckford was building his Gothick 'Abbey' on a hill in a very large, wooded estate to the SW of Salisbury Plain. He was very rich. He had just bought two famous Claudes from the Altieri Palace: *The Sacrifice to Apollo* and *The Landing of Aeneas,* 'to serve the art and credit the country'. Turner had seen them in London – 'he was both pleased and unhappy while he viewed it (*The Sacrifice*), it seemed to be beyond the power of imitation'. He was going to try though.

Turner stayed at Fonthill for some weeks in 1799 to make seven watercolours for Beckford. It was a difficult task, for the siting of the 'Abbey' was as unlovely as its conception. Always attentive to detail in his house portraits, Turner made these pencil drawings in one of his large sketchbooks. He has by

Engraving from Rutter, *Delineations of Fonthill*; after John Martin

Turner's pencil drawings of the unfinished Abbey, 1799, from sketchbook XLVII, $8\frac{1}{2} \times 13$ ins

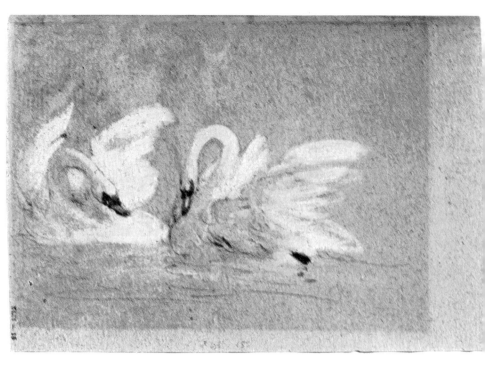

Swans: black and white chalk
and ink on brown paper
discoloured by exposure;
XLII, 15. $6\frac{7}{8} \times 4\frac{7}{8}$ ins

below: pencil drawing, part of
a page from the Fonthill
sketchbook, XLVII. Sleeping
labourers and fighting swans

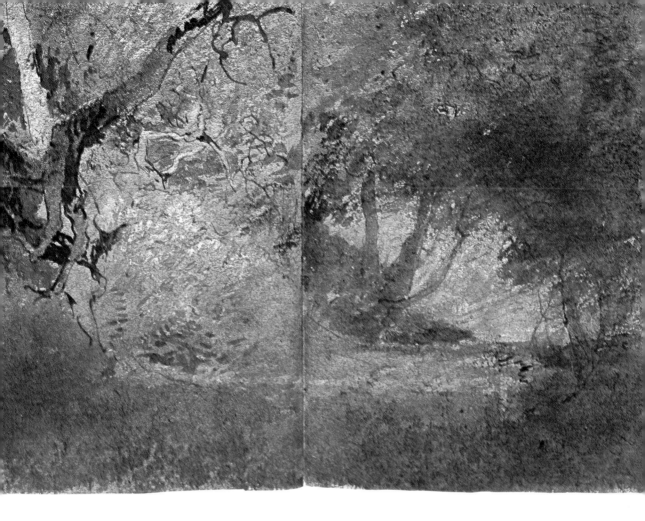

Wooded bank: pen, wash and
Chinese white from the 'Swans'
sketchbook, folios 136 7

this time a fantastic skill with the pencil –
and one must also admire his scrupulous
refusal to be awed by this hyperbolic edifice,
so that he has left a most objective record
of the building, which fell down in a thunder-
storm a few years later.

The atmosphere of the Fonthill drawings is
of a sultry late summer or autumn, with hazy
skies. As Turner wandered about the great
estate, looking for useful viewpoints, did
he reflect on Beckford's folly in spending
more than £300,000 on an architectural
extravaganza? The money came from
Beckford's possessions in Jamaica, earned by
slave labour. Labourers in England had their
wages pegged to the price of a loaf. Perhaps

all this crossed Turner's mind as he drew
the three sleeping workers: but the perfectly
harmonious forms of the swans and the gnarled
clutching shapes of tree roots may have had
more meaning for him. He was in love, and
his mother was going mad.

Sarah Danby, his mistress, was the widow
of a composer of glees, who had died at 41,
after an illness which paralysed his legs. The
Danbys had four children, and lived in
Henrietta Street, close by Maiden Lane.
Turner's first daughter by Mrs Danby was
married in 1817, and his sudden interest in
ballads dates from 1898. In the Swans sketch-
book he noted down some verses, their subject
the young sailor, his ship beset by storms,

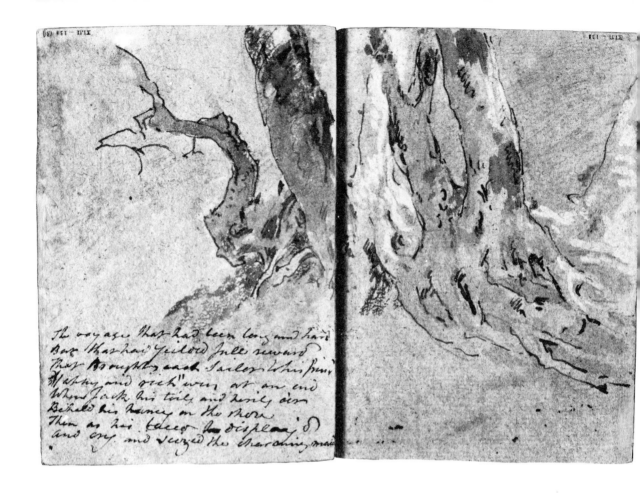

The voyage that had been long and hard
But that had yielded full reward
That brought each Sailor Whispering
"Wealthy and rich" was at an end
When Jack his toils and perils o'er
Beheld his Nancy on the shore
Then as his t... he displaid
and cry and seized the... maid

Old coppiced beech trunks, and a verse, from the 'Swans' sketchbook, dated 1798. Pen, ink wash and Chinese white on brown paper

sustained by thoughts and hopes of his loved one. The only contemporary reference to the relationships of Turner and Sarah Danby is in Farington's Diary (February 1809). Biographers before Jack Lindsay ignore her, or confuse her with the crippled Hannah, her niece, who was in Turner's service until his death.

Even denser silence surrounds his mother. She went into Bethlehem Hospital in December 1800; the signatories to her committal were not members of her family. She died in 1804 in Munro's care, but it seems that she did not have the benefit of the gentler regime of his private nursing home, as one might have expected.

Turner had turned for comfort to W. F. Wells and his family, where the daughter Clara formed a high opinion of him. She vividly remembered 'playing' beside him as he made the first *Liber* drawings in 1806, and Thornbury has her also able to remember Turner in the 1790s, treating their home as a 'haven of rest from many domestic trials too sacred to touch upon'. It may be true, for she wrote in 1853: 'All my early recollectings are so bound up with him . . . that it seems but yesterday'.

Around the end of 1799 Turner had moved to 64 Harley Street, sharing part of the house with J. T. Serres, marine painter to the King and marine draughtsman to the Admiralty –

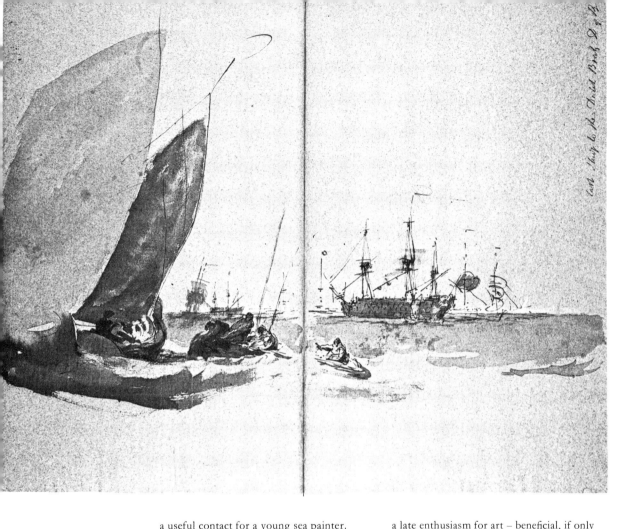

*Last study to the Dutch Boats,
D of B, pen and ink, brown
wash, chalk, on blue paper.
'Calais Pier' sketchbook.
LXXXI, 106–7: page size
$17\frac{1}{8} \times 10\frac{3}{4}$ ins*

a useful contact for a young sea painter.
Serres had a lot of trouble with his wife,
who believed herself to be a royal princess
and spent all his money. She lived elsewhere
however, and Turner soon moved his home
address to 75 Norton Street, though he
continued to occupy the house in Harley
Street. His rent there was only £40 a year.
Sarah was ostensibly at 46 Upper John Street,
which was close by.

The subjects of his pictures exhibited in 1801
were in London, South Wales and Salisbury:
and *Dutch boats in a Gale; Fishermen endeavouring
to put their fish on board* – the great Bridgewater
Sea Piece. This had been commissioned by
the ageing 'Canal' Duke, who had developed

a late enthusiasm for art – beneficial, if only
because 'It caused him to take walking exercise
about his galleries and rooms' (Farington).
The picture, something over 5 feet by 7,
changed hands recently at £340,000 – but
Turner's fee was adequate: 250 guineas. The
picture is believed to be still in Britain. It
was something like the 'Picture of the Year'
at the Academy in 1801, fascinating the press,
the public and the Academicians. Various
evolutionary stages are to be seen in the large
'Calais Pier' sketchbook – one of his studio
books of blue paper.

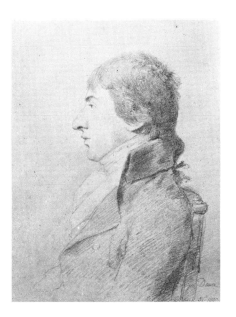

The North-east coast and Scotland

June 1801 was very hot in London. Turner was feeling 'weak and languid', and later complained of 'imbecility', as he planned a tour of Scotland, with a Mr Smith of Gower Street, to last three months. In the event the tour took only seven weeks. We don't know whether Mr Smith went along.

There are seven sketchbooks, containing over 500 drawings, connected with this journey to NE England, Edinburgh and the southern Highlands. Disparities of style and handwriting are enough to suggest that he may have travelled as far as Edinburgh in the previous year. Not enough is known of his movements in 1800 to rule this out. The 'Smaller Fonthill' book contains sketches of Yorkshire and Durham.

Some of the pencilwork in the *Helmsley* book could date from his earlier visit to these parts in 1797. Whitby, Durham, Morpeth and Norham feature largely in the pencil pages, with a cool-coloured watercolour (folio 14) early in the book, and two rapid watercolours of a rainbow passing Durham Cathedral

1801 (?)
From the Helmsley sketchbook, LIII.

opposite, top: River with distant mountains, 14.

opposite, below: Durham Cathedral with rainbow, 97.

above: endpaper — itinerary notes and accounts.
Page size 6½ × 4½ ins

Right: Turner in 1800, drawn by George Dance. Royal Academy

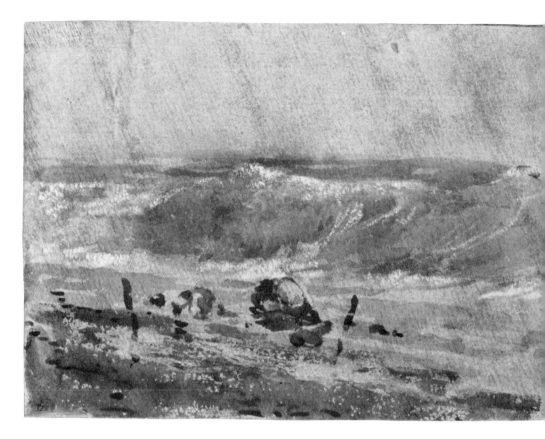

towards the end, amongst some pages used for watercolour which have been cut out. A new interest in figures is evident early in the book, but it soon fades out. A two-part list of expenses, in two different styles of handwriting, gives a summary of his itinerary: Helmsley, Pickering, Scarborough, Whitby, Guisborough, Stockton, then more or less straight to Wooler, Northumberland, where he draws a line after spending £12 8s 5d. The list resumes in a more crabbed hand at Cornhill, then down the Tweed (Norham) to Berwick and then along the coast by Dunbar to Edinburgh, where he spends £7 18s 1d. The list then takes us NW from Glasgow to Inveraray, ending at a total of £20 3s 4d. The rest of the journey – if a single journey it was – can be followed in the 'Scottish Lakes' book (pp 80, 81).

A small book of blue paper has 36 pencil and white chalk sketches mostly of rough seas and rocks. It is labelled *Guis*[borough] *Shore*. A slightly larger book of Whatman paper washed pinkish brown, labelled *Scotland* by Turner and called 'Dunbar' by Finberg, contains numerous much more effective studies of waves – indeed they are inspired. The sea of the *Dutch boats* had been well handled, but here he exults in the sweep and force of the breakers. His next sea-masterpiece, *Fishermen upon a Lee-shore*, probably emerged from these pink pages and this experience.

The 'Dunbar' book, read in the reverse order of Finberg's pagination, follows his search for Romantic ruins and rocks, from Rivaulx to Whitby and from Dunbar to Tantallon, and Roslin, south of Edinburgh. Not even the romantically named Tantallon Castle seems to satisfy him, however. The sea and the shore, in quieter moods as in folio 96a, do inspire him – but there are many more castles, to follow.

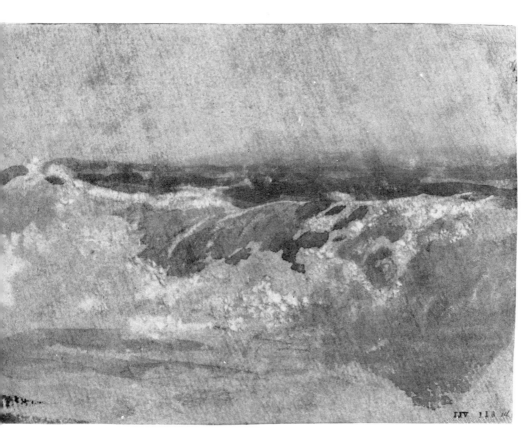

Two pages from the 'Dunbar'
sketchbook of white paper
stained with pink: brown wash
and scraping out.
LIV, 110a and 116. Page size
$4\frac{1}{2} \times 6\frac{1}{2}$ ins.

Right: *Fishermen upon a lee shore,
in squally weather*, oil painting,
exhibited in 1802. Kenwood,
Iveagh Bequest. 36 × 48 ins

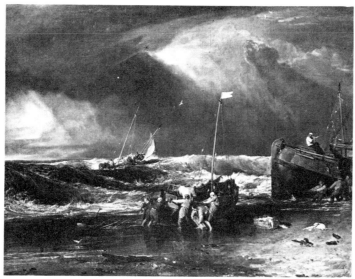

NE coast sunrise: pencil and
scraping-out on pink-washed
paper, 96a; and below, a castle,
pencil and white chalk—no
scraping, 99. From the
'Dunbar' sketchbook

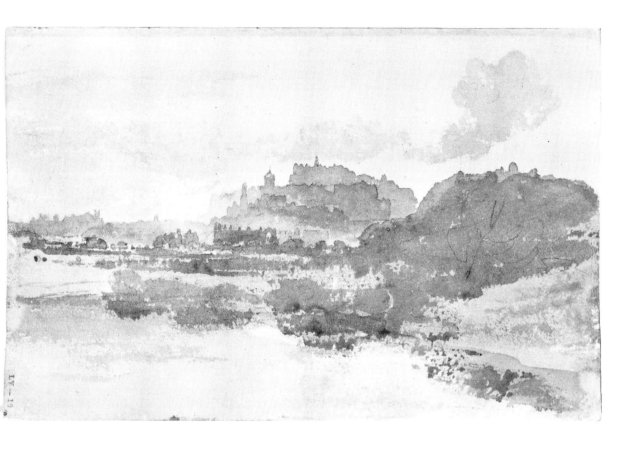

Edinburgh

Here he uses, for the first time, a flat-folding sketchbook bound in paper boards: it seems to take us out of the eighteenth century. The paper is still watermarked 1794, but Whatman and other makers used this watermark for several years to avoid a new tax, and the watermarks of all Turner's sketches before 1801 or so usually bear this date.

If we choose to relegate the material of the Helmsley, Guisborough and Dunbar sketchbooks to 1800 – and some of it may be earlier – the new style of the Edinburgh sketchbook will bear out the argument. Limpid washes establish the recession of the Castle on its hill and other hills intervening. A searching, more hesitant yet highly formal style distinguishes the pencilwork, particularly in the very harmonious houses by the water of Leith, folios 24a–25. Many views of Edinburgh Castle and Roslin are all this book contains. One pair of pages was the basis of a watercolour exhibited in 1802, *Edinburgh from the Water of Leith*.

1801

Edinburgh from St Margaret's Loch: wash drawing, nearly monochrome. *Edinburgh* sketchbook.
LV, 10. $7\frac{3}{4} \times 5$ ins

77

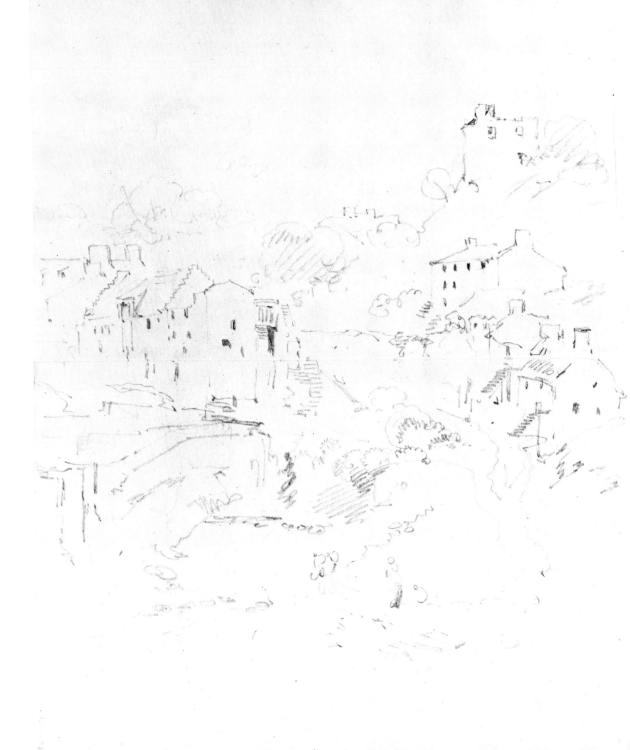

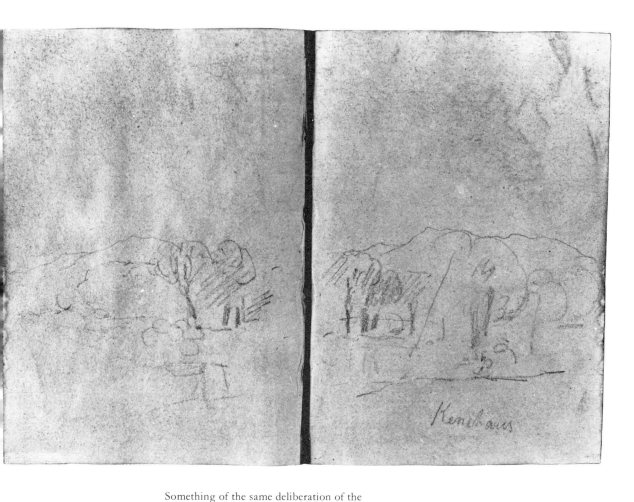

Something of the same deliberation of the
Edinburgh houses is found in a small, grey-
washed sketchbook 'Tummel Bridge'.
Kenchaus: even the writing of that word is a
visual statement of thoughtfulness. The grey
wash of the pages seems to fit his mood – it
is only occasionally scraped away, as in the
Dunbar book, and on only four pages is any
white used. Two wash drawings are nearly
monochromatic. Remarkably, out of 38
subjects, some only vague lines, no less than
sixteen can be identified amongst the Scottish
Pencils (pp 82–3), against a handful from the
'Scottish Lakes' book, which follows here.

above: *Blair Athol L. towards Kilicranky.* 'Scottish Lakes' sketchbook. 7¼ × 4 LVI, 121a, 122.

'Scottish Lakes'

There are vigorous and entirely explicit drawings amongst these 384 pages of pencil; but many appear superficial. Turner's idea seems to have been to observe each place that interested him from as many different viewpoints as possible – there are, for instance, fourteen drawings of *Kilchern*. He kept to a strict order, and his route can be followed. It later became his habit to keep this kind of record on his travels.

He mostly contents himself with the simplest lines, but when he is concerned with modelling he briskly puts in highly selective patches of tone in rapid shading, and suggests a great deal by what is left out – as in the bridge at Dunkeld.

Near Dunkeld, LVI, 135a, 136

He used sketches of Kilchern, Ben More,
Loch Tay and Stirling for compositions in
the Scottish Pencils, and one important one
of Blair Athol later emerged in the *Liber
Studiorum*, complete with a fisherman in a kilt.
Yet another sketchbook, 'Scottish Figures',
contains a few very crude costume sketches
of highlanders of 1800.

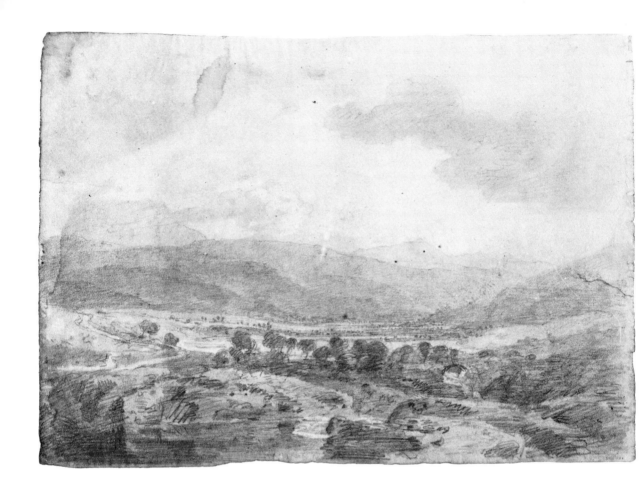

Scottish Pencils

The places which specially interested Turner were in the regions of Loch Long, Loch Fyne and Loch Tummel. Here he made seemingly superficial notes in his dark paper 'Tummel Bridge' book. He worked these and other views up into large pencil compositions. In all there are sixty sheets, mostly about 14 by 19 inches, a few 11½ by 17, some smaller. The paper is all prepared with a wash of dull brown, which Turner told Farington was mixed from tobacco juice. The sheets were pasted into a large scrapbook.

The total effect can be depressing, but the answer to that is not to look at them all together. There is an element of serious self-education, and there are many beauties and subtleties which emerge gradually. This amazing artist, with his way of planning

Winding river and mountains, pencil and chalk on brown-stained paper: Scottish pencils. 13¼ × 19¼ ins. LVIII, 24

82

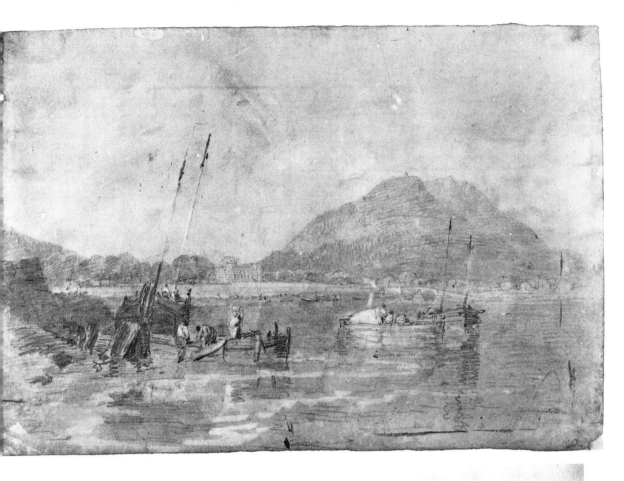

Inveraray Castle,
13 × 19¼ ins. LVIII, 9

right: from the *Scottish Figures*
sketchbook. LIX

pictures in batches of fifty or more, repeated
the process in watercolour on his return from
the Rhine in 1817, again using tinted grounds,
and when in Rome, in a large sketchbook of
tinted paper, again in monochrome.

His 74 line-and-wash drawings for the *Liber
Studiorum* are in (sepia) monochrome, but *all*
his drawings specifically for monochrome
line-engraving are in colour – for the later
steel engravings often in very bright colours.

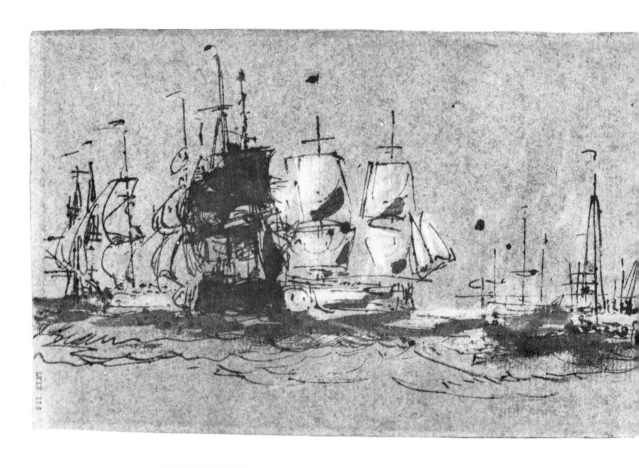

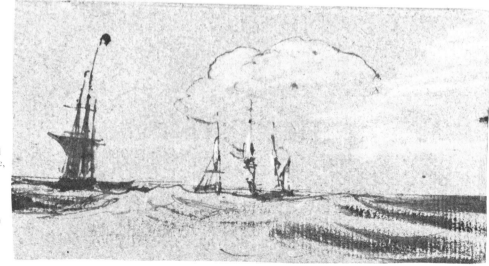

Sea pieces in pen wash and chalk on blue paper: above, from the *Studies for pictures* sketchbook, LXIX, 119; 8½ × 5½ ins (faded)

below: from the 'Egyptian Details' sketchbook, LXVI, 2; 6½ × 3 ins

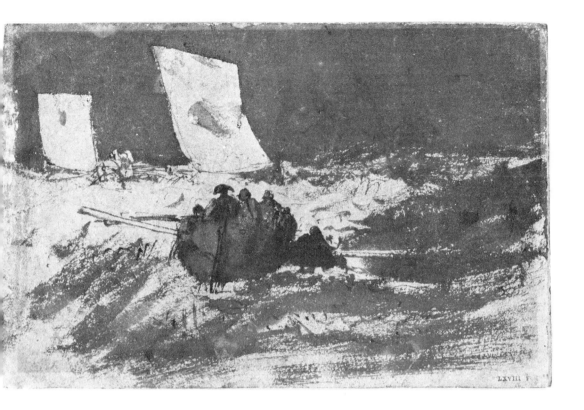

Study from 'On a Lee Shore'
sketchbook, LXVIII,
$4\frac{1}{2} \times 7\frac{1}{8}$ ins

Academy pictures

In February 1802 Turner became a Royal
Academician, and in the Exhibition he had five
oils and three watercolours. Two of the oils
are among his finest early sea pieces. In the
small (3ft by 4) *Fisherman upon a Lee shore, in
squally weather* (at Kenwood) the credibly
painted fishermen themselves are the focus of
a composition designed to express the force
of wind and waves (see page 75). *Ships bearing
up for anchorage,* twice as big, was the first of
his work to be bought by Lord Egremont (of
Petworth). It is a lively but classical com-
position in which the ships, their sails counter-
pointed dark on light, circulate majestically
(round the intersection of two golden means).

The ships at left were part of the preparatory
work for the Egremont sea piece. Other
arrangements appear, also on blue paper, in
the large Calais Pier study book. The smaller
sketch is from yet another blue paper book,

called 'Egyptian Details' because of some small
sketches.

A large history painting (nearly 5ft by 8)
justified Turner's new title of RA: the *Tenth
Plague of Egypt.* This again is a very strongly
constructed composition. Turner referred back
to this and to the Egremont sea piece for
Liber plates, as he did two other pictures from
this year, *Jason,* and a very large watercolour,
Fall of the Clyde, which is now at Liverpool.

Kilchurn

The other watercolours were of *Edinburgh;*
and *Kilchern Castle with the Cruchan Ben
Mountains* – and with a large rainbow, two
peasants in costume based on his sketches,
and some goat-like sheep among foliage of
unlikely proportions. This watercolour is now
at Plymouth. While the foreground is charm-
ing in its way the large compass, the air and
breadth of the composition are remarkable,

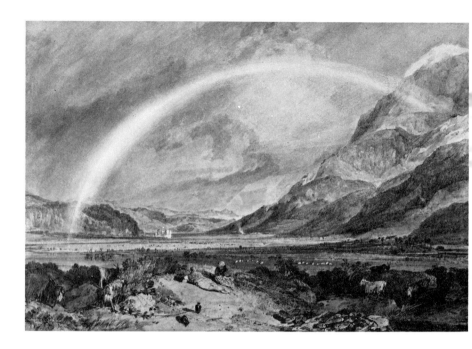

and entirely justify the contrivance of the
rainbow's arch. The subject derives from the
Scottish Pencils and the Scottish Lakes
sketchbook, but the scale is much exaggerated.

The 'Jason' Sketchbook

Turner later called his picture of *Jason* (about
to stab the serpent which guarded the Golden
Fleece) 'an old favourite with some' – but it
had remained unsold. He engraved it in Part
One of his *Liber Studiorum*. A single, hardly
decipherable sketch in this book provides
the excuse for the name. The rest of the draw-
ings are notable for a mature economy and
firmness. Some of the subjects are very simple:
three pages of leaves – laurel, larch and
horsechestnut – with notes; a Margate hoy
in a flash of sunlight, two rowing boats drawn
with masterly facility in pencil and wash;
some copies of pictures; many blank pages
and leaves removed. At folio 4 is the brilliantly
analytical pencil landscape reproduced on
p.88: hard to date, this, as early or late. It
could be 150 years later.

*Kilchurn Castle, with the
Cruchan Ben Mountains,
Scotland, Noon.* Watercolour,
1801. Plymouth Museum
and Art Gallery

right and opposite: pages from
the 'Jason' sketchbook, LXI
Laurel, 63 and a Margate Hoy,
55a, 61

1802

The year of Turner's achievement of his first
ambition, and the year in which he first
travelled abroad, is a natural turning point. It
may be useful to summarise the material of
the Turner Bequest gathered between the
Scottish Tour and Turner's departure for
Switzerland. The last sketchbook of the
Scottish tour is 'Scottish Figures', LIX.

LX Watercolours on Scottish subjects – rather
similar in size to the Scottish Pencils; ten
drawings, A–J, all faded through late
Victorian exposure. J, *Inveraray,* has an 1808
watermark.

LXa 'English Lakes', all on Imperial paper
($21\frac{1}{2} \times 30$ inches) watermarked 1794. Finberg
redated these from 1801 to 1809, but they
are now agreed to be all of Wales, deriving
from the tours of 1798–9.

LXI The 'Jason' sketchbook.

LXII 'Cows' sketchbook. Eleven slight
sketches of cows.

LXIII 'Colour Bill' sketchbook: five boats and
a bill of artists' materials from J. Newman
totalling 11s. 2d.: 'Large Bladder [tube of]
White, 1s. od.; Large Varnish brush,
1s. 6d.; six hard lead pencils, 2s. od.'; etc.

Rapid pencil note from the
'Jason' sketchbook, LXI, 4

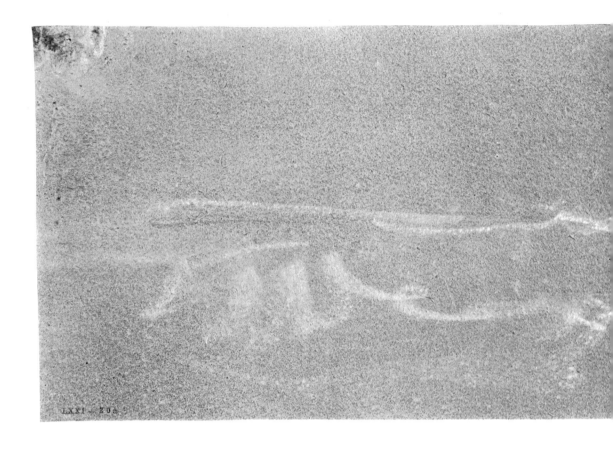

LXXI - 20a

France and Switzerland

In the middle of July 1802, Turner, RA, set off
to explore the Alps, in search of scenery
even more inspiring than the mountains of
Wales and Scotland. The Treaty of Amiens
had brought the hostilities between France
and England to an uneasy halt. Girtin had
managed to stay in Paris in the previous winter
and spring but he had to draw his views of
Paris from a carriage to avoid unpleasantness
from passers-by.

Our Landing at Calais. Nearly Swampt, wrote
Turner on one of several versions of this
incident in the 'Calais Pier' book: *Our situation
at Calais Bar,* and so on. On future foreign
travels he was to paint watercolours of mishaps

in the snow of the Alpine passes, for his
friend Fawkes – he is rarely so overtly
autobiographical.

In this case the incident enlarged itself into
a great oil painting, *Calais Pier, with French
poissards preparing for sea: an English Packet
arriving,* exhibited in 1803 and causing some
head-shaking amongst Academy colleagues
and the critics.

In the 'Small Calais Pier' sketchbook, which
he carried with him, he filled several tinted
pages with waves in white chalk, in the excite-
ment of the moment extending his rapid
sketching style into a new sort of free calli-
graphy. Other drawings of Calais in the
sketchbook are quite sedate, as if in reaction
to the drama of the landing, but as he travels
through France to Switzerland there is no
mistaking the sense of freedom and exuberanc

1802

'Small Calais Pier' sketchbook,
LXXI: 20a, 21, chalk and pencil
on grey-washed paper, and right:
pen and ink, page size $4\frac{3}{8} \times 7\frac{1}{4}$ ins

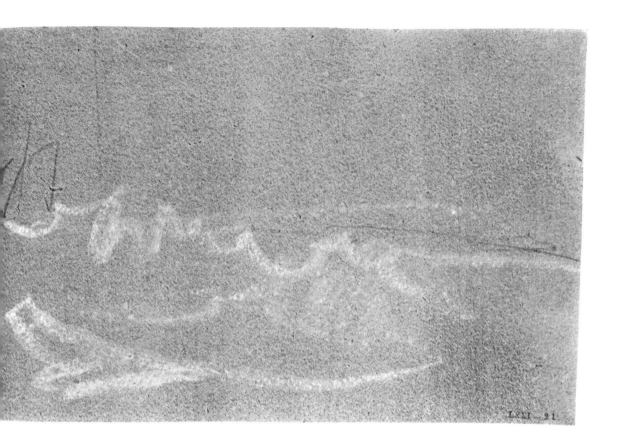

in his line. From this time on he was always
able to change, as it were, into top gear,
producing flourishes of connected elliptical
notation; outlines and masses reduced to the
simplest terms. Carried to excess, as it some-
times seems to be, this manner can conceal
more than it explains – at least to the observer
if not to Turner – but it has left us many
vivid images, and it has some bearing on the
simplifications of form characteristic of his
later paintings.

Where the balancing of solid masses of tone
is essential, he works in tone, shading with
pencil or chalk – very boldly compared with
the Scottish Pencils of only a year before. In
Paris he bought at least one sketchbook of a
pleasant warm tinted paper, so that he could
pick out the snow of distant peaks in white, or
build up his designs in the thoroughgoing

chiaroscuro that is typical of his Alpine work.

He joined in the purchase of a 'cabriole' with another traveller of whom we know nothing: it has been suggested (Herrmann 1975, p 228) that it was Walter Fawkes: plausibly, for Fawkes became the owner of many of the watercolours that resulted from the Alpine journey. It is a pleasant thought that this most fruitful relationship should have been formed so early and in the shared hardships and moments of vision of the Swiss tour. Hardships there were, though Farington may

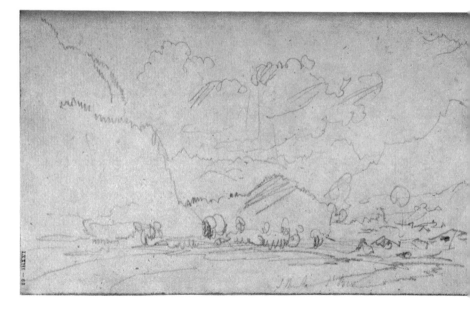

Avallon, 12, and below, Alpine valley, 62, from a book of pale brown paper bought in Paris, the *France, Savoy Piedmont* sketchbook. LXXIII. 8¼ × 5⅜ ins

Castle on a Lake, from the 'Grenoble' sketchbook.
LXXIV, 46. $11\frac{1}{4} \times 8\frac{1}{2}$ ins

exaggerate: 'He found the wines of France and Swisserland too acid for his constitution being bilious. He underwent much fatigue from walking and often experienced bad living and lodging. The weather was very fine. He saw very fine thunderstorms among the mountains' – so he did!

The book of tinted paper, bought at 'Coiffier, Marchand de Couleurs et de papiers, no 121, Rue du Coq Honoré', continued in use from Paris through Autun and Macon – no hint of the Festival he was to paint – to Lyon. Then, from the order of the pages in this *France, Savoy, Piedmont* book – his own label – it appears that he went first to Geneva and through Chamonix and Chambery to Grenoble, and then back again to Chamonix to tour the Mont Blanc region. According to Finberg (1939) he would have gone straight to Grenoble from Lyon.

At Bonneville (SW of Geneva) he got down to work in earnest, using a larger sketchbook of hand-tinted Whatman paper, the 'Gothard and Mt Blanc', and a sheaf or book of brown pastel paper loosely called the 'Grenoble sketchbook'. Curiously enough, the first water-colour in the large sketchbook is much closer than the others to the Scottish Pencils, both in technique and in mood (see the cover of this book). This drawing was used for a painting (1803), a watercolour for Fawkes, another similar watercolour, and a *Liber* plate as late as 1819.

The 124 loose leaves of the Grenoble 'sketch-book', a squarish rectangle about $11\frac{1}{2}$ by $8\frac{1}{2}$ inches, are in no sort of order. Twenty-seven of them escaped Finberg's catalogue, and Ruskin cut off most of Turner's labels (though he preserved them in an envelope which is still there). A reconstruction of the order in

Thunderstorm in the mountains.
LXXXIV, R; about 11¼ × 8½ ins

which these drawings were done would be of some value, for their styles vary to extremes, as may be seen from the few examples reproduced here.

The 'Defile of the Grand Chartreuse, about 9 miles long', he told Farington, was 'abounding with romantic matter'. Whether it was the wine, too acid for Turner, or his impetuosity in the face of so much fine material, he produced a series of wild, over-vigorous pencil and chalk drawings – the manner, without the dramatic unity, of the thunderstorm at LXXXIV R. Perhaps he was simply getting used to rapid work on his new pastel paper with what seem to be much softer chalks than he was used to. Many of these drawings are really crude, and a possible theory is that he went over his original pencilwork in a fit of frustration, desperately trying to knock them into stronger shapes.

In only one of these leaves of brown paper he uses washes of a strong yellow ochre and black to heighten the chalk and pencil. All the Swiss drawings seem to have been conceived in monochrome, the usually very warm colours emerging from the tonal background to give added depth to his already strongly carved modelling. Where the Scottish Pencils had been subtle, these are bold. He makes much use of triangular masses and shapes.

After the untypical Bonneville drawing, the style of the watercolours in the St Gothard book becomes more direct, and the brushwork vigorous. Most of these drawings could have been finished on the spot. There are a dozen more or less completed in colour in the book, and there are pages at Dublin, Manchester (Whitworth), and Cambridge and (two) in the Courtauld Collection.

Leaving the Haute Savoie, Turner, and

presumably his companion, went over the St
Bernard pass and down the Rhône to the
Castle of Chillon. He then went to the Lakes
of Lucerne and Thun. The large sketchbook
was used for some pencilwork, especially at
Thun (see the frontispiece), and then again
for a series of heroic watercolours in the St
Gothard Pass itself.

At Thun he began a small book of white
paper, 'Lake Thun', which records by contrast
unemphatically, but in leaping and curving
line, his excursions around Interlaken, to the
St Gothard and to Lucerne. He glances at the
Rigi and goes on to Zurich and Lauffenberg
and down the Rhine to Schaffhausen. Here

we find that he carries with him the large
Fonthill sketchbook, either to use up the blank
pages or to have some of his best drawings
to show to anyone he might meet – perhaps
both. The drawings of Schaffhausen and Basle,
in pencil only are, utilitarian, but they provided
two plates in the *Liber*.

Another book of paper of a laid surface –
like the Lake Thun – he labelled R[hine] *from
Strasburg. Oxford*. In fact it reaches back to
Grindelwald, touches the Rhine, and then has
some drawings of Nancy and Ligny-en-Barrois
on the way back to Paris. It contains a fine
pencil study for *Apollo and Python* (1811) and
an atmospheric view of Oxford's spires.

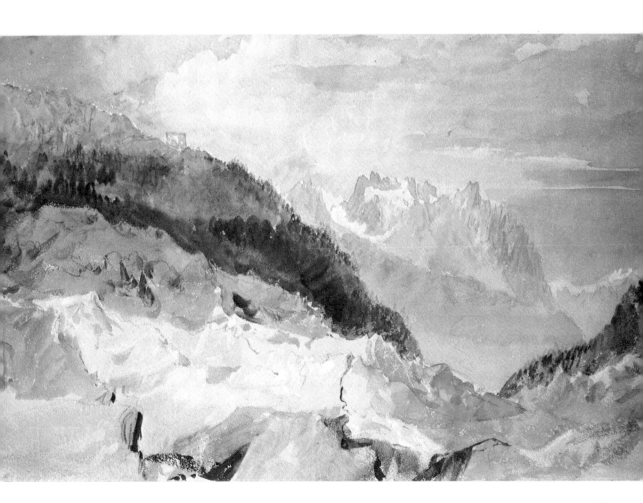

Return to Paris

A further small sketchbook, again squarish in proportions, contains the unique watercolour here, and several pages of a carnival or procession, rapidly sketched and tinted, for the costumes, in flower-like colours. Some rather weird groups of peasants make up a total of nineteen figure subjects as against over 400 landscapes on the tour.

'The people were well inclined to the English', he told Farington, whom he met in Paris on 30 September. Farington and other English artists were there chiefly to see the work of David, and others now forgotten. Turner stayed in Paris for perhaps three weeks, spending much of his time in the Louvre, where there were many great paintings 'acquired' by Napoleon from the cities of Europe. He made extensive notes in a tiny sketchbook which had the pages washed in grey and red. He copied pictures by Ruysdael, Raphael, Titian, Poussin, Correggio, Giorgione, Domenichino, Rembrandt and Rubens. He noticed only one contemporary, Guérin, a painter of classical subjects which the Parisians interpreted as anti-revolutionary.

Watercolour from the 'Swiss Figures' sketchbook,
LXXVIII, 1. $7\frac{3}{4} \times 6\frac{1}{4}$ ins

right: sketch for *Apollo and Python; Rhine from Strasbourg,* Oxford sketchbook,
LXXVII, 43a. $6 \times 9\frac{1}{2}$ ins

He thought the Rembrandt's *rather monotonous* (in colour); *the lights are spotty*; the *Susanna finely coloured in shoulder and loin, the piece of white drapery admirable*, but on the whole *miserably drawn and poor in expression*. Of Ruben's Landscape with a Rainbow: *distorting what he was ignorant of . . . natural effect*; of the Tournament – *one continual glare of colour and absurdities . . . but captivating*.

About Ruysdael, too, his feelings are mixed: *A brown picture which pervades thro' the water so as to check the idea of its being liquid – altho' finely pencil'd.* He was to paint a sort of 'homages' to Ruysdael in 1827 and 1844. Another Ruysdael was *A fine coloured grey picture, full of truth and finely treated as to light which falls on the middle ground.*

He found that the reds and blues of the Poussins had been touched up – or he could not believe the colours were so 'unhistorical'. A Poussin had 'defective' lines, an 'ill-judged' waterfall, a woman 'unworthy of the mind of Poussin'. *Whatever might have been said [of the Deluge] by Rousseau never can efface its absurdity as to forms and the introduction of the figures, but the colour is sublime. It is natural . . .*

Of Titian he wrote nothing but praise. The Alphonse de Ferrare and Laura de'Diante was *A wonderful specimen of his abilities as to natural colour, for the Bosom of his mistress is a piece of Nature in her happiest moments* (the picture was then called Titian and his Mistress). By the copy of Titian's Entombment reproduced here he wrote:

This picture may be ranked among the first of Titian's pictures as to color and pathos of effect, for by casting a brilliant light on the Holy Mother and Martha the figures of Joseph and the Body has a sepulceral effect. The expression of Joseph is fine as to the care he is undertaking, but without grandeur. The figure which is cloathed in striped drapery conveys the idea of silent distress, the one in vermillion attention, while the agony of Mary and the solicitude of Martha . . . are admirably described, and tho' on the first view they appear but collateral figures yet the whole is dependant on them . . . Mary is in Blue, which partakes of crimson tone, and by it unites with the Bluer sky. Martha is in striped yellow and some streakes of Red, which thus unites with the warm streak of light in the sky. Thus the Breadth is made by the 3 primitive colours breaking each other, and are connected by the figure in vermillion to the one in crimson'd striped

drapery; which balances all the breadth of the left of the picture by its Brilliancy. Thus the body of Jesus has the look of death without the affected leaden colour often resorted unto . . .

In almost every case Turner starts his observations with a note on the colour of the ground. It takes a professional eye to pick this out. Working into a white ground was virtually unknown in oil painting until Turner himself changed the tradition a few years later. Of *St. Jerome by Correggio* he wrote: *Painted upon a rich ground rather green, so that the first colour produces a neutral tone approaching to Green or Brown as cold or warm colours are used; thus arrises the Beautiful cold grey through all the flesh of the infant and Virgin.*

A full transcript was made by Finberg in his *Inventory*.

our Situation at Calais Bar

From the 'Calais Pier' sketchbook, LXXXI, 70. Page size 17⅞ × 10¾ ins

opposite: *The last study for the picture of Macon Lord Yarborough Bought*, LXXXI, 116, 117

The *Studies in the Louvre* sketchbook is placed before the Swiss sketchbooks in the *Inventory*. Numbers LXXIX and LXXX are drawings, usually large and some in pencil only, of Swiss subjects, either done on the spot or based on sketchbook material.

LXXXI, the 'Calais Pier' book, is rather confusingly named. It is a large upright book of thin blue paper, and it probably never left Turner's studio. In it he had drawn, usually in black and white chalks and sometimes in pen, and brown wash, studies of his oil paintings from 1801 to 1805 and later. In 1805 he seems to have gone through the book labelling the studies in ink. These pages were of course the only reference he had for pictures he had sold. The inadequacy of such records to represent oil paintings may have been part of the reason for starting the *Liber Studiorum* in 1806.

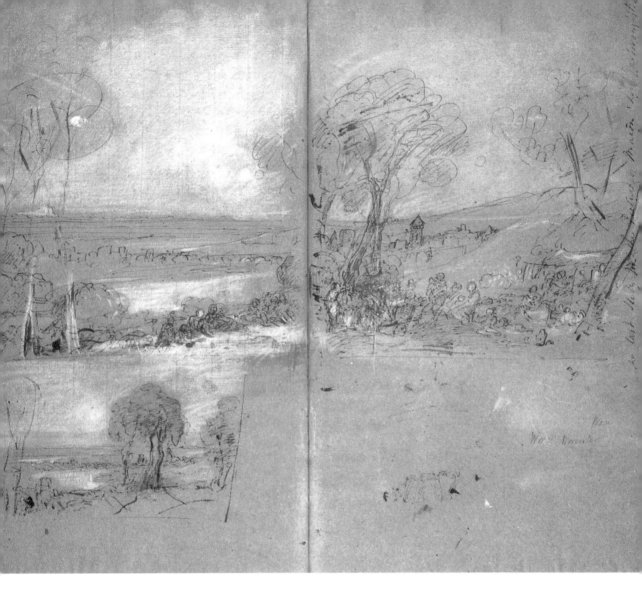

Some subjects in the 'Calais Pier' book are listed below (Turner's labels in italic: no date means 'painting not known').

The Shipwreck	1805	Tate
Jason	1802	Tate
Lake of Geneva	1810	Los Angeles
Calm (Sun rising through Vapour)	1807	National Gallery
Willm Tell escaping from the Boat		
Hannibal	1812	Tate
Holy Family	1803	Tate
Parting of Venus and Adonis	1803	Tate
Death of Adonis		
Macon. Ld Yarborough's Picture	1803	Sheffield
Hero and Leander	1837	Tate
Calais Pier	1803	Tate
Lord Egremonts Picture	1802	Petworth
Mr Dobree's Lee Shore (The Wave)	1802	Southampton
Study for the Deluge	1804	Tate
The Water turn'd to Blood		
Edinburgh	?	

1803–1811

Helmsley Castle, folio 5, and a castle on a crag, 64; both from sequences of drawings in the Chester sketchbook.
LXXXII. $10\frac{1}{8} \times 6\frac{1}{2}$ ins

Between 1803 and 1811, when Turner was aged 27 to 36, definite dates for his work are few, apart from some important pictures which were not necessarily close to the mainstream of his imagination. His sketches on the Thames, clearly central to his inspiration, cannot be placed in order of production, and his less formal paintings were shown in his own gallery, largely undocumented until 1810. There are no sketchbooks specifically dated

1803 and 1804, except for a nearly blank, calf-bound book, $6\frac{1}{2} \times 4\frac{1}{2}$ inches in which he made a few slight notes of an eclipse occurring in February 1804. The pages are all prepared with a brown wash, 186 of them not used.

In dating the *Chester* sketchbook Finberg, always cautious, is unusually vague: 1801–1805(?). Turner's labels say *36 Yorkshire Pickering Scarbro'* and *Chester*. He still signs himself, on an endpaper, W. Turner: a habit he changed to J. M. W. Turner in 1802. Some of the Yorkshire drawings are early, before 1801 by their style, while the drawings of Helmsley Castle and of another castle, on a

crag, – which I feel I ought to be able to identify – look later. The careful verticals of Helmsley remind me of Farnley sketches of 1815 to 1818, and the brisk shading of the crag is certainly post-Swiss. The vertical format of these drawings is unusual. They are both parts of sequences in which Turner builds up his image from different angles. Drawings of Chester could have been done in 1808, when Turner visited Tabley House, in Cheshire.

A little book containing about 70 nudes and other figure drawings was titled 'Academies' by Finberg, this being his euphemism for 'nudes'. It is dated 1804 by inference from a list of commissions for Swiss subjects – ending: *Small picture for 100 for Mrs. Lee.* On another page another list includes a *Historical Whole Length 300 Ld Carysford* and *Sea Piece: Small do. 10 Mr. Bannister. Mr. Tomkinson.* I would like to see these modestly priced sea pieces. At the end of the book is a note: *Gt Devils Bridge causeway/Upper Fall of Richenbach/Mt Blanc from St Martin Mr. Fawkes 50 G.e.* Christian names were not commonly used, but I think that if Turner had had Fawkes' company in Switzerland he would have dropped the *Mr* by now.

Some of the figure drawings, five of which are coloured, have the feeling of the life-room: others are a little more intimate. Few are without faults of drawing.

Sea pieces

In April 1803 he had ready for the Exhibition two oils of *Bonneville, the Festival of the Vintage at Macon, Holy Family* (a result of his studies in the Louvre) and *Calais Pier.* No one seems to have liked *Calais Pier,* though it drew a lot of attention. It was of course well ahead of its time as the first of Turner's restless 'vortex' pictures – though it is strongly based on traditional geometry.

There was 'too much of the square touch', said Lawrence: the water was 'like veins in a marble slab' – which doesn't sound too derogatory. Farington collected adverse comments. He thought Turner was getting above himself – with 'a great deal of *aim* in them', his oils were 'crude, ill-regulated and unequal', – but he continued to make notes about Turner's watercolour technique. Hearne

said the sea in *Calais Pier* 'appeared like butter'. The critic of the *Sun* wrote, 'a lamentable proof of genius losing itself in affection and absurdity . . . incongruity and confusion. The sea looks like soap and chalk'. Kitchen similies were in order for witticisms about Turner's paintings.

From this time on, Turner was cast as the eccentric genius. But eccentric patrons, and, later, the public through engravings, continued to support him, and indeed made him wealthy. To Fuseli, Lawrence and a few others his genius was never in doubt. Younger artists were said to have their taste 'debauched' by him: the *True Briton* christened him the 'Over-Turner'. Constable, his near contemporary but slower to develop his powers, thought he was out of touch with nature.

In the summer of 1803 Turner might well have decided to stay in London. Apart from whatever were the demands of his mysterious home life, he had a great deal of material collected in his sketchbooks, and plenty of commissions for watercolours based on these. He took his duties as an RA seriously – too seriously, it appears, at a time when the Academy was riven with controversy about its autonomous powers. Farington quarrelled with Turner in 1804 in a council meeting and told him that 'his conduct as to behaviour had been a cause of complaint to the whole Academy'. After this scene, Turner absented himself from most Academy functions for some months.

He was supervising the building of his own gallery, opened in April 1804. It was attached to his house in Harley Street and large enough to show twenty or thirty pictures. (He must have bought the lease of the house he formerly shared as a tenant, with J. T. Serres.)

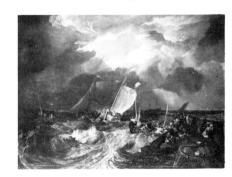

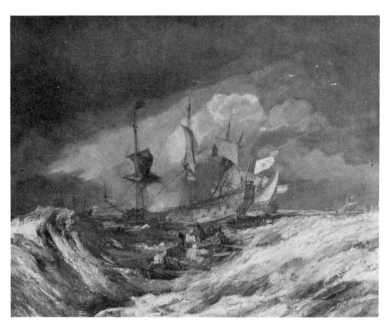

Boats carrying out Anchors and Cables to Dutch Men of War in 1665. 1804, oil, 40 × 51½ ins. Corcoran Gallery, Washington, D.C.

1804(?)

opposite: Endpaper and two pages from the *Studies for Pictures, Isleworth* sketchbook: XC, 21; study for *Dido and Aeneas*, 1814, and 20, State Barges. 10 × 5¾ ins

He took the picture away from the Exhibition before it closed, and delivered it to its owner, Samuel Dobree. Perhaps this fortunate man appreciated how Turner had developed his dry scumble of white to represent a searing spindrift, the attention he had given to the rich colours and complex patterns of the sails against dark clouds, the controlled but palpable sense of romantic adventure.

In April 1804 Turner's mother died in the Home for Incurables attached to Bethlehem Hospital.

Again he appears not to have travelled far in the summer. He had his new gallery to look after: in later years he would leave his father or his servant Hannah Danby in charge. It is now known that he had his 'country cottage' at Isleworth as early as 1805, so he may have already started, in 1804, the great series of Thames sketches and paintings.

Isleworth

The sketchbook which Turner called *Studies for Pictures, Isleworth* was dated 1805 in the Inventory. Then in 1936 Finberg corrected the date to 1811, because he thought that Turner took Sion Ferry House at Isleworth after his stay in Hammersmith, while his Solus Lodge (later Sandycombe) was being built. Now it appears that he wrote a letter dated 1805 from the Isleworth address, and this address is also found on the back of the painting, *Windsor Castle from the River*—see the sketch overleaf. We can now take the notes with the date 1804 on the endpaper of the Isleworth book, seriously. But another colour sketch, folio 21, very close to the *Dido and Aeneas* of 1814, does not help this early dating. The only reasonable supposition is that the sketchbook was started in 1804, on the Thames, but that the classical 'roughs' were done later – perhaps, as in folios 38a and 39, he was using riverscapes of 1804 to suggest compositions of 1813 and after. The sketchbook is crowded with material in several different media – including a lot of pen and ink – and must have been used over a long period. The fluently limned ceremonial barges of folio 20 remind us that in Turner's day the Thames had its scenes of grandeur not too far removed from the Carthage of his imagination. But in

In 1804 he sent another great sea piece to the Academy: *Boats carrying out Anchors and Cables to Dutch Men of War in 1665.* This picture is at Washington. How the somewhat obscure incident came to have any importance for Turner we can only guess. The Dutch (apparently in 1666, not 65) had to cut their anchor cables when surprised in rough weather by the British Fleet. Perhaps Turner had been borrowing Serres' books on Naval History. Just as he had invested his Welsh castle pictures with historical significance, so, perhaps, he was anxious to ensure that his sea pieces were seen as more than salty genre works or reminiscences of Van de Velde.

Even though the Navy and its traditions of alertness and command of the seas must have been in everyone's mind with the restarting of the war with Napoleon, the gesture fell flat. The *Sun* thought his choice of subject 'affected ... there is nothing in the subject to excite an interest. The figures are very indifferently formed, and the sea seems to have been painted with a birch broom and whitening' Farington reported Opie as saying that the water 'looked like a Turnpike Road over the sea', and Northcote as supposing that 'Turner had never seen the sea'.

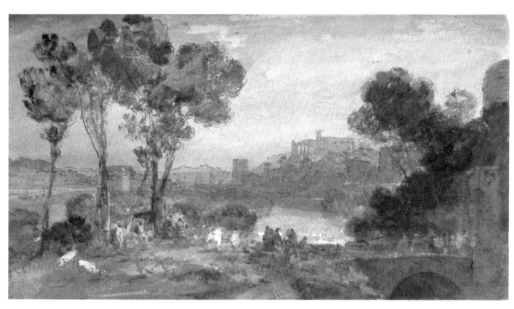

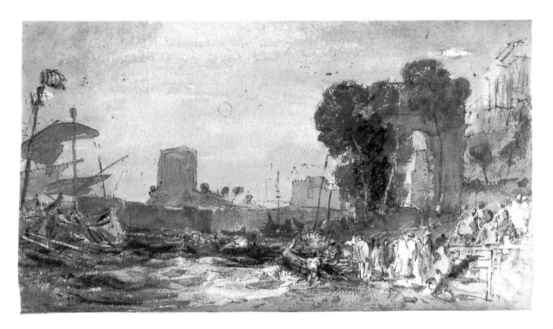

Study for an embarcation scene, 38a; and
below: sketch for *Windsor Castle from the River* 1804, from *Studies for Pictures, Isleworth*: XC, 29a.

the years 1803 and 1804 Poussin and Titian were the objects of Turner's emulation, not the Claude who is always present in the Carthage pictures. There may be a Claudian influence in *Macon* (1803) but his feelings for Claude are first clearly expressed in 1807, in *The Sun rising through Vapour* and in the first plate of the *Liber* to be engraved, plate 13, which Turner called *Walton Bridge*, and plate 3, which he called *E P Claude*. In his Thames sketches his guide was not Claude or any other master. His style is purely naturalistic.

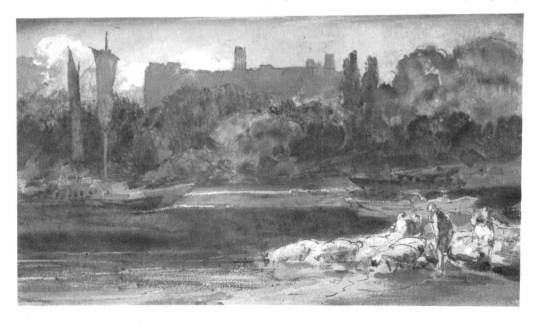

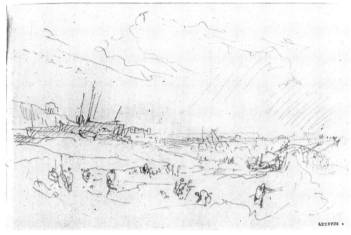

The Shipwreck, 1805

Turner exhibited his important *Shipwreck* in
1805 in his own gallery, and sent nothing to
the Academy. In the gallery with it were
perhaps *The Deluge* and *The Destruction of
Sodom,* both '6 × 8 s' now in the Tate Gallery,
and *Adonis Departing for the Chase,* with un-
sold paintings, such as *Jason,* and water-
colours such as the Swiss subjects for Fawkes.

He sent a packet of invitations to the R.A.
to be delivered to the members by the porters.
The Society of Painters in Watercolour
opened its first exhibition at the same time, in
Brook Street. Hoppner told Farington that he
went from there 'to Turner's Exhibition
which having seen the delicate and careful
works at the former Exhibition, where so
much attention to nature was shown, Turner's
room appeared like a *Green Stall,* so rank,
crude and disordered were his pictures'. The
reference to green seems to suggest that
some of Turner's Thames oil sketches may
have been on show at this early date: they
might have seemed disordered in 1805.

Two small sketchbooks with paper covers
contain Turner's many studies for his *Ship-
wreck* (others are in the *Calais Pier* book) and
a series of rapid, vivid pen-and-ink records of
a ship breaking up close to shore, with people
searching among the debris in the surf. Most
of the composition studies are variations on
the large sweeping curve and the pendulum/
mast which are elegantly employed in the
picture. There, the peak of the sail of the
rescue boat takes the place of the naked mast
of the studies, the point of the sprit exactly
reaching the centre line of the picture at its
intersection with a golden mean of the vertical
dimension. Various clear diagonals support
this precarious boat within the picture plane.

Sir John Leicester bought the picture at the opening of the exhibition. Charles Turner, who had been at the Academy Schools with J.M.W., engraved and published a large mezzotint: fifty copies at 2 guineas and proofs at 4 gns. The painter apparently had no profit from the venture apart from a few proofs, but he made a list of some of the subscribers in one of the Shipwreck sketchbooks, presumably in 1806 when the engraving was published. On one page, not catalogued by Finberg, appears the preliminary sketch for his own, much longer publication, which began in 1807.

In the Autumn of 1805 Trafalgar was fought (off Gibraltar) and Nelson's body was brought in his flagship to the Thames estuary. Turner painted *The Victory beating up Channel* (bought by Fawkes) and he went to Sheerness to draw the ship and her personnel. His sketchbook includes a visualisation of the scene at the height of the battle. The painting, shown in an early state in his gallery in 1806, was entitled *The Battle of Trafalgar as seen from the Mizen starboard shrouds of the Victory*. It is in the Tate Gallery.

He worked hard in much of his painting and topography to make it meaningful to ordinary people. His impetus was not 'journalistic'; rather it was his sense of history taking contemporary form.

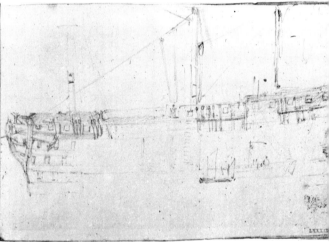

1805

Nelson's dismasted Victory, and a study for the oil painting of 1806-7, from the *Nelson* sketchbook: LXXXIX, 28a, 29 and 26. Page size 4½ × 7 ins

106

Sussex and Liber Studiorum

Studies for Pictures, Isleworth is no 90 in the Inventory. Roman no 91 is a vague, slight sketchbook of dark tinted paper which Turner labelled: *Coast, Lewes Hurstmonceux Pevensey G. Winchelsea*. It seems too early in style for the '*Coast*' to refer – as it might in Turner's abbreviated style – to the second phase of Cooke's *Southern Coast*, for which there is one sketchbook, CXL, *Hastings to Margate*. It might be connected with *Views in Sussex* (p 140) because it contains some drawings of Bodiham Castle. But there is not enough evidence to alter Finberg's 1804–6(?), though he never gave a reason for it (it was probably the *Winchelsea*, mentioned below). The drawings are rather flat, in spite of being 'heightened' with white chalk. Many of the pages are spotted with rain.

The first note of *Liber Studiorum* from the *Shipwreck* No 1 sketchbook

Hurstmonceux Castle, XCI, 39. Approx. 8 × 5 ins. Pencil and chalk over grey-brown wash

the latter, if there was any sign of his hand being jogged: there isn't, it's all smooth and rapid, but barely intelligible.

The East Gate Winchelsea page may have started as another scribbled outline, being filled out later with the nicely balanced tones which by hindsight look like mezzotint, for the drawing was used, without the windmill and with a lot of added detail, for a *Liber* plate published in 1819. Another page was developed in a similar way for *Winchelsea* (Liber plate 42, 1812), with the meaningful addition of a returning soldier. This sketchbook is also dated 1804–6(?).

The *Liber Studiorum* had its almost legendary beginning in the autumn of 1806, in Wells' cottage at Knockholt in Kent, as recounted by Wells' daughter Clara, a lifelong friend of Turner's. 'No one would have imagined,' under that rather rough and cold exterior, how very strong were the affections which lay beneath', she wrote. According to her, Turner was 'goaded' by her father into embarking on the *Liber* – to make his reputation safe against imitators.

Hesperidean

Turner's label on the first of the two 'Hesperides' sketchbooks reads only *71 H*: but Hesperidean is a good description of the atmosphere of the sketches in both these books, which range up and down the Thames from the Medway to Abingdon, always rich and full of pattern. Some notes for the serpent in the picture, *The Goddess of Discord choosing the apple of contention in the garden of the Hesperides*, exhibited at the British Institution's opening exhibition early in 1806, gave Finberg the title.

The sketches on the Thames are interspersed with ideas for classical subject paintings, so that we imagine mythological figures lurking in the riverside willows, and classical temples glimpsed through the mist on the waters. A study for a picture of the London River (in Turner's Gallery in 1809?) is vague enough to be a Carthaginian harbour scene: another, perhaps of London Bridge, is treated in rich Venetian red, and blue. Monochrome studies for *Dido and Aeneas* and others give the impression that their lighting at least was studied in Thames-side banks and meadows.

Sketch used for *East Gate, Winchelsea*, plate 67 of *Liber Studiorum* and above, another page from the *Sussex* sketchbook: XCII, 44 and 19. 8½ × 5⅞ ins. Pencil over grey or brown wash

The next book, labelled *Sussex*, is also colour-washed throughout. It has many leaves missing. The drawings, far from being flat, are mostly wild, excited, landscape scribbles – as if subjects appeared too fast to be taken down. He might have been in a hurry, or he might have been in a coach – I would believe

Hesperides II is slightly smaller than the other, and all in monochrome. (Both have their paper tinted in greys.) Here Turner works consistently in pen and ink, sometimes with wash as well. The pen emphasises the calligraphic nature of his line in rapid but still evocative sketches of Sutton Courtenay (*Sutton Mills*), Culham (*Culem Bridge*) and Abingdon.

Studies appear in both books for the picture once called *Abingdon* and now rechristened *Dorchester Mead* (from a list of exhibits in Turner's gallery in 1810). The beautiful misty effect of the picture is not in the sketches, though the direction of the light (evening, if this *is* Abingdon bridge) is expressed in the way the wading cows are drawn, in folio 4a.

1805–1807(?)

Drawings of Culham Bridge, near Abingdon, and Abingdon Bridge and church from Abbey meadow, from the 'Hesperides II' sketchbook. XCIV, 39a and 40a. 9 × 5¾ ins. Pen over grey wash

below: the picture now called *Dorchester Mead* 1810(?). Oil. 40 × 51 ins. Tate Gallery

Thames from Reading to Walton

A large roll sketchbook, which Turner labelled thus, contains a rich cross-section of his work on the middle reaches of the river. In fact it goes well beyond Reading to Goring, and down beyond Walton to Kew Bridge, the subject of one of the finest watercolour pages.

Pencil and watercolour are used in a variety of ways. Some of the pencil drawings are bolder and more complete than might be expected if they were only the framework of watercolours to be; most of the watercolours are finalised (without being 'finished') beyond the point of being sketches for something else. He composes in the comparatively large page as easily as if it were one of his pocket books: the small 'roughs' of Walton Bridges (folio 22) are not typical. These bridges appear also in

the Hesperides II book. One of the two oil paintings based on the sketches was paid for in January 1807, which suggests that it may have been exhibited in Turner's gallery in the previous summer and sketched in the summer before that, 1805.

There are no classical compositions in the large *Thames* book. It is entirely concerned with places, some of them labelled in Turner's 'exploring' manner. If it is the counterpart on paper of the Thames oil sketches on panels, it is also certainly earlier.

The house by the river (folio 48), part of a curiously bisected composition, is at a stage of incompleteness which reveals most of Turner's basic watercolour methods: washes varying from transparent to almost solid, blotting out, scraping, dry brushwork and gum-thickened medium. See page 127

Pangbourne Lock: Thames from Reading to Walton sketchbook, XCV, 16. $10\frac{1}{8} \times 14\frac{3}{8}$ ins
below: part of a page containing sketches for a painting of *Walton Bridges*

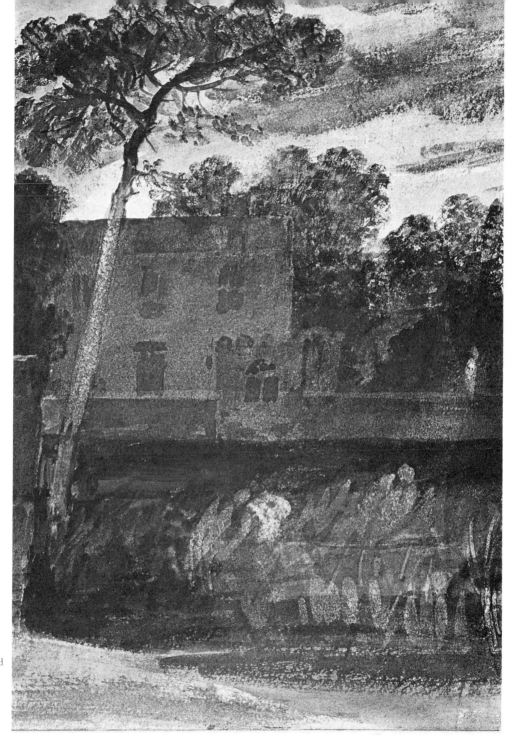

Detail of the right-hand
half of folio 48 of the
*Thames from Reading to
Walton* sketchbook.
Watercolour on white
paper

Spithead

Hammersmith, about 1807

These two pages compress material from five smallish sketchbooks – and perhaps from three years. Turner's labels in italics:

XCVI *River. JMW Turner/West End, Upper Mall/Hammersmith*
XCVII *Windsor Eaton*
XCIX *River and Margate*
C 'Spithead.' Turner's title: *Shipping. River Thames* (late autumn, 1807)
CI *Boats, Ice*

I have had to leave out some wonderful pages: skies in pencil with descriptive colour notes; details of boats and strange juxtapositions of sails; glimpses of trees and cows and intriguing bits of riverside architecture. All the books are packed with material observed from life: the common theme is of people at work in the field or on the water. Turner is collecting material for his pastoral *Liber* plates, and studying people for their behaviour, not just their dress. The first two books, as their titles suggest, are based on the river, but with many excursions into the surrounding countryside.

The *River and Margate* sketchbook, full of choppy waves, contains a survey of the estuary coastlines. *Hastings Fish Market* gets in somehow, possibly because the boat he was on went there. There are notes and diagrams, and some rough prices, for another boat, perhaps Turner's own.

In the autumn of 1807 he went to Spithead to draw the Danish ships that the Navy had snatched from neutral Copenhagen to keep them out of Napoleon's grasp. They made one of his most magnificent ship compositions, but he changed the title to *Spithead: boat's*

crew recovering an anchor because the action
became the subject of political controversy.
On the way back from Portsmouth he
collected *Liber* subjects: some of his most
melancholy and intense pastorals. The season
was late, and the dark mood which pervades
*Hind Head Hill, Water Mill, Hedging and Ditch-
ing* inspired Ruskin, in a fine, misguided
passage (Modern Painters V, 336) to find this
gloom and despair to be the true theme of
the *Liber Studiorum*. On one page is a composi-
tion sketch using the material of the *Sun rising
through Vapour* (1807) perhaps for the second
version now at Birmingham.

Number 101, *Boats, Ice*, takes us out with a
fishing fleet, the sun setting in *Fire and blood*.

at Sudeley Castle, Gloucestershire), perspective notes. He became Professor of Perspective at the R.A. in December 1807, after the death of his own teacher, Edward Edwards. Turner was the only candidate.

Pack ice immobilises a ship in a scene which surely cannot be at the mouth of the Thames (above)?

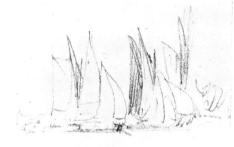

In 1808 he stayed for some weeks at Tabley Hall, Cheshire, to paint it for Sir John Leicester. A fellow guest said he had spent most of his time fishing, but he certainly was not idle. Three sketchbooks associated with Tabley show him vigorously pursuing all his interests: reflections in water, verse, Liber subjects, even learning the flute; and carrying out his assignment superlatively well. The largest book contains a careful 'layout' for one of the pictures, and, with 'Tabley no 1', was also used in Lancashire: Ribblesdale, and Whalley in particular, for a painting of Whalley Bridge.

above: from the *Boats, Ice,* sketchbook.
right: from the 'Greenwich' sketchbook. CII
below: two drawings from a sequence in the 'Tabley No 2' sketchbook. 1808. CIV

A very small book, *Greenwich*, dated 1808, completes the sequence of notebooks associated with the years 1806–8 on the river. It contains a fine series of racing yachts, anticipating 1827 at Cowes, verses for *Pope's Villa* (1808, now

The bridge of CIV, 10 may be the source of the *Liber* (?) sketch on page 123. With folio 15 it is part of a sequence of this hilly road, perhaps on the Cheshire border of Wales.

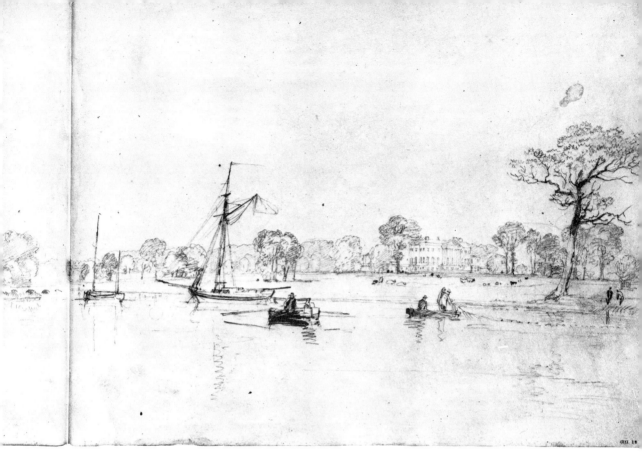

Tabley Hall with Sir John
Leicester's Yacht: 'Tabley
No 1' sketchbook.
CIII, 16 and part of 15a. Page
size about 9 × 11⅞ ins

right: pen sketch for *Tabley:
Windy Day* exhibited 1809.

below: *Large Eel Hooks—Patent
Yellow.*
CIV, 54a

Egremont 1809

above: from the 'Derbyshire' sketchbook, CVI, and below it, from the *Kirkstall* sketchbook, CVII, both about 7 inches wide

top right: from the 'Perspective' sketchbook, CVIII, *Another proof of power of secondary lights.*

bottom right: from the *Hastings* book, CXI, 66. The last two are about 4½ ins wide

Two of Turner's small pencil books are associated with Derbyshire and with Kirkstall Abbey in Yorkshire. The 'Derbyshire' book is as wide-ranging as a good novel, with notes of all kinds and verses, as well as delectable, sometimes atmospheric, drawings of rivercraft and ruins, and some pen and ink: a bridge over the Dove, an imposing mansion, a wild rose. *Kirkstall* contains fifteen serene, but very faint, views of the Abbey ruins and two pages of boats: that is all. He may have gone to Farnley in 1808 or 1809 – there are notes of routes to Otley.

A very small (3½ × 4½) 'Perspective' notebook really is that, with the addition of verses to *Dear Molly*, and other poems. His poetry is

becoming more personal. In this year, 1809, occurs the only mention ever of Sarah outside Turner's wills. In Farington's diary for February: 'A Mrs Danby, widow of a musician, now lives with him. She has some children.'

A commission to paint Petworth House followed the Tabley successes. Again Turner produced a large, careful study for the 'house portrait': *Petworth House, the seat of the Earl of Egremont: Dewy morning*, exhibited in 1810. Another limpidly accurate drawing is of Cowdray Hall, near Midhurst. An average-sized pencil book, *Frittlewell* (or Frittleworth, near Petworth?) contains very attractive drawings of a Sussex village and two more-than-usually intelligible pieces of verse. One is about a wet day, the other is to his virgin sketchbook: *The spotless innocence retreats . . . Yet Hope looks back as heretofore and smiling seems to say encore.* Both are quoted in full in Lindsay (1966); 32 and 33.

One of his smallest books, 'Hastings', about 1809–11, contains vignette-like groups of figures, trees and boats. Some lengthy accounts

Drawing for *Petworth, Dewy Morning* from CIX. 5. $8\frac{7}{8} \times 14\frac{1}{2}$ ins below: two pages from the 'Frittlewell' book. CXII. $4\frac{1}{4} \times 7\frac{1}{4}$ ins

yield to Finberg, not to me, the facts that Turner had stocks valued at £7216 16s 2d, estimated the 'probable advantage' of the *Liber Studiorum* at £2000, and valued some land, his books and furniture, and his unsold pictures, at enough to bring his total worth to over £12,000 – this in 1810.

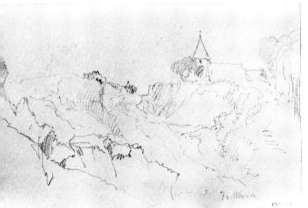

Egremont also owned Cockermouth Castle, and Lord Lonsdale commissioned paintings of Lowther Castle, Westmorland. Turner's sketchbooks of these places are confidently dated 1809. *Cockermouth*, CX, contains a series of light pencils of Calder Abbey rather like those of Kirkstall: vivid notes, visual and verbal, of the surroundings of the castle and

1809

above and right below: from the *Cockermouth* sketchbook: Cockermouth Castle: Calder Abbey; *In wet weather they wear Blue Horseman Cloaks with Hoods; Calder Bridge.*

top right: from the *Hastings* sketchbook, continued.

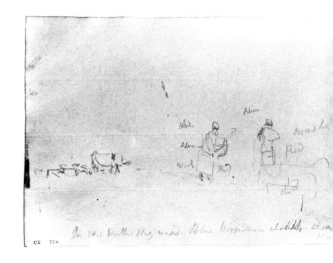

Double spreads and pages from the 'Lowther' sketchbook, CXIII. $3\frac{1}{4} \times 4\frac{1}{2}$ ins

of local people and what they wore: clogs and cloaks.

The small book, 'Lowther', does contain details of Lowther Castle, but I imagine the rich variety of interior subjects to have come from Egremont's castle – he was a notably relaxed character with a complex domestic life. But Turner is back on the Thames, it seems

on folios 29a–30, estimating builders' costs on folio 13 and the inside cover, and writing a poem to *Laura* on folio 65. On folio 59 he notes: *Woman is doubtful love* – the heading perhaps of a poem torn out on the following page. The model with her hair tied back *may* be Sarah: the cradle *may* have been Georgianna's.

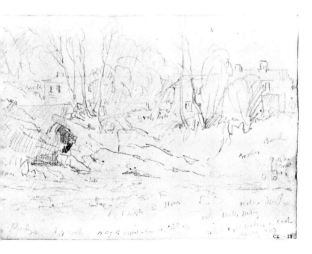

The last of Hammersmith

Turner frequently filled up whole sketchbooks of 96 pages or more in a week or two, when he was travelling. But he also kept some books going for years, particularly if they contained studies for pictures. He might return to these for ideas and sometimes might add new material. Other books he partly filled with drawings of one place and then used up the blank pages in another place at another time. Clearly, any sketchbooks may be a combination of all these and provide a nice puzzle for anyone who wants to give it a date.

The *Wey, Guildford* sketchbook was originally placed by Finberg in the context of the pencil and pen notebooks grouped on pages 112–113. But it is different. Its nearest relative is the *Studies for Pictures, Isleworth* book which is now known to have been started before 1805 – with material added perhaps in 1813. There is nothing in the Wey. Guildford book to suggest an early date, but there *is* a study labelled *Chryses*, and the picture with this title and composition was exhibited in 1811 – now in a private collection.

The book itself divides into two parts separated by 70 blank pages. The classical subjects are all together at one end, mostly in brown wash and line, and the pencil drawing on the Wey and Thames are at the other.

The pencil work is spare in character. The street in Guildford (?) is like some Devonshire townscapes of 1811, though much less complex. The very stylish Eton sketch might be of any date from 1802–1832, as in Switzerland, Avignon or Edinburgh he would drop his linear style, momentarily, to create a small, complete picture. Other pencil drawings are of Newark Priory, visible from the Wey Navigation, and St Catherine's Hill, Guildford.

John Gage has recognised a connection between some of the oil sketches on panels which he dates 1809–10, and this sketchbook. (R.A. 1974, page 68.) 'None of the viewpoints are identical' – why should they be, if all were done from nature?

1810, therefore, seems a possible date for both parts of the sketchbook. The classical compositions include *Ulysses (deriding) Poly (phemus)* (1829) and *Dido and Aeneas* resorting

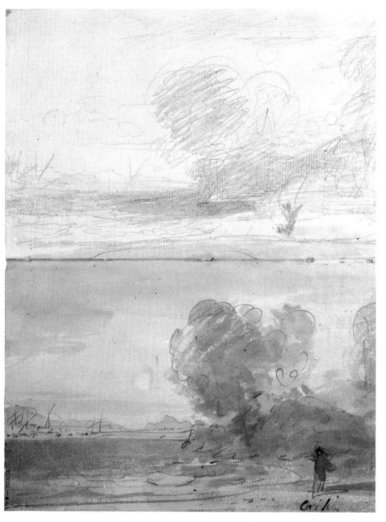

'to the Shady woods for sylvan games', but
amongst Thameside willows and without the
'Tyrian Court' of the verse, by Dryden,
attached to the picture of 1814. (p 103.)

Chryses, Mercury and Herse and *Apollo and
Python* were all exhibited in 1811, the first
mythology pictures since the *Hesperides* in 1806.
The relationship of Mercury to the Greek
Herse is obscure, at least to me. Apollo simply
kills the Python, not without the aid of a
superior being. But Chryses

> . . . in the anguish of a father mourn'd;
> Disconsolate, not daring to complain,

> Silent he wander'd by the sounding main.
> (Pope, *Iliad*)

Was this a picture of Turner, who was
shortly to wander on the Southern Coast?
The gradual build-up of love lyrics in Turner's
versifying, and the sudden rush of mythology,
must mean something. The house at Hammer-
smith was empty by 1812 and Turner resumed
his habit of sketching tours in the summers:
perhaps commissions happened to come along.
He moved round the corner in Harley Street
in 1811, apparently adding to his existing
property and changing his address to *Queen
Anne Street West/Corner of 64 Harley Street*.
When he built his villa at Twickenham (1813)
he called it Solus Lodge (later Sandycombe)
and eventually decided that it was wasted
because he had never lived there for long
enough at a time: he sold it in 1828.

The reappearance of *Dido and Aeneas*, also
seems to be no accident. These characters
(Dido, founder of Carthage, Turner's favourite
location; Aeneas, wise warrior, with heavenly
connections) I am sure Turner used to sym-
bolise his life with Sarah. The first Aeneas
picture is dated about 1800: that of 1815 was
his favourite painting: he returned to the
theme in his last working year, 1850.

At Hammersmith he had established the real
themes of his work: landscape always related
to life. He had aquainted himself with the
deep emotions which are a person's true
'drives'. He had studied the countryside as it
appeared to him, and not as it was supposed
to look according to this or that canon of
taste, and he had pioneered new styles of oil
and watercolour to serve his vision. He had
mastered a style of sea painting which could
cope with calm and storm. He had embarked
on an important series of illustrations.

He could now sign himself, and did, RAPP.
He interpreted his brief on Perspective widely.
In his lecture on *Backgrounds*, first delivered
in 1811, he hailed his master, Claude: 'Pure
as Italian air, calm, beautiful and serene, spring
forward the works and the name of Claude
Lorraine.' Where could we find a clue to his
mode of practice? Only through 'continual
study of the parts of nature', claimed the Pro-
fessor – who was in fact rather averse to
studying 'parts', and remarkably adept at pro-
ducing 'wholes', whether from nature or not.

(ostensibly over a small increase of fee) with his namesake Charles, who had mezzotinted 24 of the plates; and began to employ a team of engravers, taking a hand himself on some plates. Meanwhile W. B. Cooke and his brother George were to engrave and publish Turner's first important topographical series, *Picturesque Views on the Southern Coast of England*.

The sepia line and wash of the Wey, Guildford sketchbook is very reminiscent of the *Liber* drawings. The design labelled *Chryses* was adapted with only small changes for *Glaucus and Scylla*, a finished but unpublished plate. The beautiful classical composition of folio 14, seeming not so much sketched as spontaneously brought to being, takes us back to *Isleworth* – significantly, in reverse, as if the idea had occurred to the artist while he drew on the waxed plate. *Isleworth* in the *Liber* was not published until 1819, but the design almost certainly dates from 1804–5 because the view is from a point very near Sion Ferry House.

Drawings for *Liber Studiorum*

In 1811 he found line engravers who could interpret him. Pye and Heath engraved his *Pope's Villa* of 1808 for John Britton's *Fine Arts of the English School* (1811). Pye, apparently on Turner's suggestion, also worked on the large *High Street, Oxford* published in 1812. Heath again did the figures (he had considerably improved the scale of the figures and giant sheep of *Pope's Villa*). He was to be closely associated with Turner for many years – to his ruin as publisher of *England and Wales*

On the *Liber Studiorum* Turner quarrelled,

Ulysses Poly . . . and a classical composition, folios 5 and 14 from the Wey, Guildford sketchbook.

right: *Isleworth*: plate 63 of *Liber Studiorum*, published in 1819

The subtitle of this series of 70 plates – planned to be 100 – was: *Illustrative of Landscape Compositions*'. This was the only 'text' Turner published to what must be regarded as neither more nor less than a manifesto.

His contemporaries saw merely an ad hoc series of essays in the Historical, Mountainous, Marine, Architectural and Pastoral aspects of landscape which Turner used to group his designs, adding a further category, 'EP', which

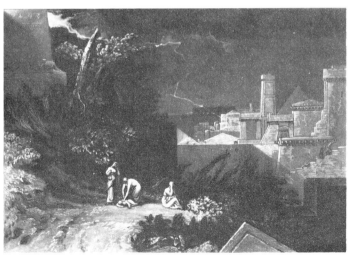

Brown monochrome wash
drawing from the sketchbook
called 'Studies for *Liber*'
CXV. $9\frac{1}{8} \times 14\frac{7}{8}$ ins (sight, 13 ins).
Left: *Tenth Plague of Egypt*; a
Historical plate (61, published in
1816), from *Liber Studiorum*.
$7 \times 10\frac{1}{4}$ ins
'And all the firstborn in the land
of Egypt shall die . . .' The
painting on which the plate is
based (but with much compressed
and formalised composition)
was exhibited in 1802. The
insistent use of compositional
device—in this case diagonals
and triangles—is typical of the
Liber plates.

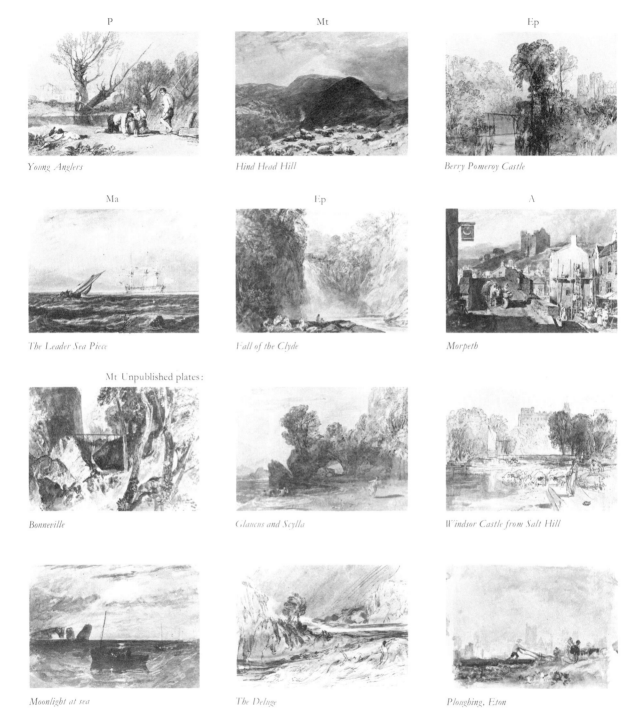

P

Young Anglers

Mt

Hind Head Hill

Ep

Berry Pomeroy Castle

Ma

The Leader Sea Piece

Ep

Fall of the Clyde

A

Morpeth

Mt Unpublished plates:

Bonneville

Glaucus and Scylla

Windsor Castle from Salt Hill

Moonlight at sea

The Deluge

Ploughing, Eton

Liber Studiorum drawings, CXVI and CXVII, all about $7\frac{1}{4} \times 10\frac{1}{4}$ ins

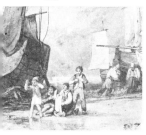

Mt

, Scotland

Ma

Dabblers

st

('Silent Pool')

contained his elevated, epic or merely extra pastoral subjects in the tradition of Claude. Charles Turner, who was left with a lot of spare proofs, used them to light the fire – 'robbing his children of a fortune', as he said later.

Ruskin saw the series as a poem of despair, conveniently ignoring the cheerfully gauche scenes of boys at play, writing off some Swiss subjects as 'slight, ill-considered and unsatisfactory', and ignoring the far from melancholy sea pieces. A certain gloom is inseparable from the heavy brown inks which were used to print the plates. The mid-Victorian, Hamerton, concentrated on the preliminary etchings, which were Turner's own work, and concluded that, though they had a 'masculine economy', the technique was poor.

Late Victorian critics such as C. F. Bell admired the series for its safe pictorial approach, reassuring to a school which had failed to notice French Impressionism for 40 years. Bell published reproductions of the 70 plates and the Frontispiece, getting all but the Frontispiece in the wrong order.

Rawlinson collected and described the many different states of the engravings (there were several stages of retouching and refurbishing to get as many as 170 impressions from plates that were worn after 20 'proofs' and 30 prints). Finberg, adding some complicated research on watermarks, also concentrated on the collector's point of view, but, in a monumental volume (1924) reproduced all the drawings, etchings and proofs, including the unpublished plates. He accepted the simple explanation of Clara Wheeler, that her father, Wells, had persuaded Turner to publish the work, 'to make his reputation safe with posterity'.

It remains for the series to be properly assessed as Turner's most ambitious early opus, with all its faults. Reynolds strikes a judicious note: 'while the first thoughts for plates in the series are among the most spirited of Turner's drawings, the finished models for the engraver have some of the dullness of uniformity, and this is still more true of the plates themselves. Perhaps they evoke a sense of disappointment because they rely too strongly on the design, the bare bones of composition and the topographical facts of landscape, omitting the atmospheric veil which Turner casts over his best work'.

It is true that the *Liber* does not fit in to the accepted idea of Turner, and the plates have many faults and weaknesses. The idea of Turner the great colourist, in brown monochrome, needs adjusting to, to start with. But these 'bare bones' as organised in the fourteen 'chapters' of Turner's treatise, deserve a more sympathetic study than they have ever had.

The title, and the manner of engraving, were taken from the mezzotints by Richard Earlom after Claude's *Liber Veritatis*. Earlom's earlier two volumes, published in 1777, were rather crude and boisterous, but his prints of Claude's drawings in the so-called third volume of *Liber Veritatis*, published from 1802, were much sounder, and could have influenced Turner, though he would be familiar with many of the originals.

He published the work himself, aquiring much of his reputation for meanness in the way he handled it. For a time, until they quarrelled, Charles Turner took over the publication, but after Part 4 the mezzotinting was thrown open to, at various times, thirteen other engravers besides Turner himself. Most of the plates were based on sketchbook material probably conceived as *Liber* material, but he included usually a version of one of his paintings in each part. Up to 1811 or 1812 the subjects occupied him greatly and, I believe, influenced the course of his work, particularly his interest in people in the landscape. There was a break following the publication of Part 10 in May 1812, after which he appears not to have worked on any new material except *Berry Pomeroy* and the unpublished *Stonehenge at Daybreak*. Two parts were published in 1816 and two more in January 1819, then no more. He had a further nine plates ready etched and plenty of material for the remaining 21 plates of the hundred. Eight of the unpublished plates were in pure mezzotint without preliminary etching. The fact that he soon took up mezzotint again, without etching, suggests that he was tired of the line-and-tone approach: he was probably tired of being his own publisher, and by this time had other engraved series going for him.

He did approximately actual-size, right-way-round sepia cartoons for nearly all the plates. These are not, of course, sketches, but working drawings. Our sixteen tiny reproductions may give some idea at least of their variety.

Watercolour sketches

A painting exhibited in 1809 was called *The Garreteer's Petition*; one of Turner's genre pieces intended to beat Wilkie at his own game. Wilton (BM 1975) points out that Hogarth was the immediate inspiration for the 'Distressed Poet' of that painting. A critic in 1809 said that Turner had better stick to his first floor in Harley Street and 'never more wander in garrets'. The sketch here is for a companion piece, which seems not to have been painted. It is now called 'The Amateur Artist': surely he would be a professional if he

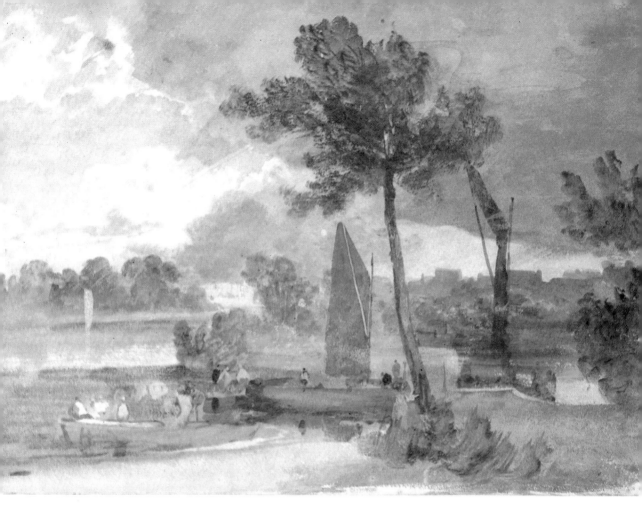

had an apprentice. Verses on the reverse end with: *The Master loves his Art, the Tyro buttered rolls.*

'Colour beginnings' – Finberg's term for watercolours without obvious constructional devices – are a famous category of Turner's unexhibited work, usually very difficult to date. Here, in a tiny notebook, not too precisely dated 1809–14 and called 'Finance' because it is a pocket accounts book, is an early 'colour beginning', a masterly blot.

The picture of the Thames (near Windsor?) is from the large *Thames, Reading to Walton* sketchbook (see pages 110, 111). Windsor

Castle appears symbolically perhaps – he had already included it in a large watercolour of the Welsh mountains (*c.* 1797) – for this busy backwater has the look of being derived from Brentford. The placing of the barges' sails is clearly unsure – but it is a considerable sketch.

Watercolour of the Thames with Windsor Castle from the *Thames from Reading to Walton* sketchbook, XCV, 12. 10⅛ × 14¾ ins

127

Hulks on the Tamar, from 'Colour
Beginnings', CXCVI, E. About
10 × 13 ins

1811 and the *Southern Coast*

Turner gave his first perspective lectures in January 1811. John Taylor of the *Sun*, an unpredictable critic of Turner's, wrote: 'The lecture was written throughout in a nervous and elegant style and was delivered with unaffected modesty.' Others said it was inaudible; but there were magnificent illustrations, held up by an assistant at Turner's instruction. No one has doubted the thoroughness, the seriousness of purpose and breadth of Turner's approach to his subject. The transcripts, even when edited by such scholars as Gage and Ziff, still make difficult reading. Though many illustrations survive, a publication of Turner's lectures illustrated by himself does not seem a practical possibility, sadly. Here is my paraphrase of a piece included as an Appendix by Gage (1969).

Amongst the mutable and infinite contrasts of light and shade the most difficult to define and relate to ordinary vision are reflections. Reflection is part of every natural effect, but it evades all theory. An effect which seems permanent on one day may be quite changed on another by a different atmosphere.

Our climate is variable: all seasons may be recognised in a single day; a vaporous turbulence involves the face of things. Nature in all her dignity seems to sport, providing incident and revealing hidden depths for the artist to study. If the human mind (as an eminent writer has suggested, like a vegetable) needs a mild warmth to inspire without langour, and a gentle cold, to clarify and to check redundance, how happily is the landscape painter situated here, where changes occur so quickly, demanding his admiration and response, so that he may store his mind with an infinite variety of times and places.

As our best art has shown, the theories of Winckelmann, Montesquieu, Dubos (etc, Gage refers to James Barry's *Works* as the source of these) about our northern climate are refuted. Let us not be blind to the abundant advantages nature has given us, but go on to prove the superiority of the northern genius by practical effort, not theoretical speculation.

It is my pride that these are English lectures: it is natural that we should deal with English effects. If we recall the Italian masters only infrequently it does not mean we think lightly of them. What they have done, and we have not, must be given due weight. The charms of Claude, and all that learned Poussin drew, we rate highly – and recognise their truth to their own climate. To the calm, serene, atmospheric tints of Claude we may contrast the sombre majesty of Poussin. We may say perhaps that Nicholas and Gaspar Poussin sometimes introduce English effects into Italian compositions. In *Pyramus and Thisbe* and *Dido and Aeneas* respectively they used the clouds of a northern atmosphere. The *Chase* of Claude must be classed as purely Italian . . .

. . . But we are inferior to these men only by our weaker efforts and talents, not by any external disadvantage (of our surroundings). They made what they did from their own surroundings: we should do the same from ours. An endless variety is on our side, opening new fields of creativity. If only we make use of the tools that Salvator Rosa has given us and adapt the high style of Poussin and the warm light of Claude to our English soil we shall reap a great harvest.

In the summer he set off for Devon and Cornwall, making little drawings and writing verse in a guide book interleaved with blanks.

'Devonshire Coast No. 1 sketchbook', actually a guide book with blank pages used for drawings, CXXIII. $4\frac{1}{2} \times 3$ ins

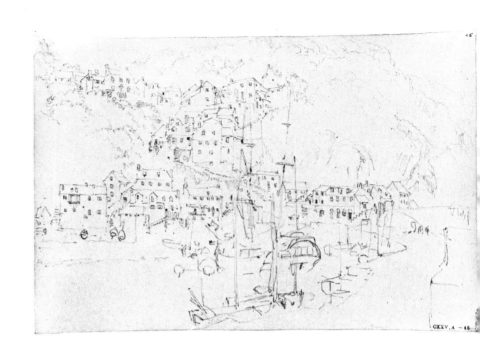

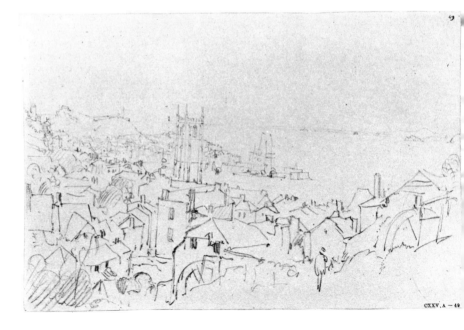

1811 or 1813

Unidentified drawings on separate sheets listed as CXXVa 'Cornwall and Devon': sheets 45, 49 and 76. $5\frac{1}{2} \times 8\frac{1}{2}$ ins

below: hulks in Plymouth Sound,
from 'Devon Rivers No 2',
CXXXIII, 29, 28a. 7 × 4¼ ins

Some of the best of the 250 or so drawings
in Devon and Cornwall come from two batches
of separate sheets which have been added to
the Turner Bequest since Finberg made his
Inventory. The two groups are numbered
CXXVa and b, the latter being concerned with
Stonehenge.

He had a list of places to draw (CXXIII, 5) and
he crossed off the subjects, about nineteen of
them, as they were done. For the rest, he
followed his own inclinations. The prison
hulks on the Tamar appear briefly in an 1811
book. He hoped to provide a verse comment-
ary to the engravings of the *Southern Coast*
but the publishers rejected it.

*Snowstorm: Hannibal and his army crossing the
Alps,* with the first acknowledged quotation
from Turner's MS *Fallacies of Hope,* exhibited
in 1812, finally cut him off from his peers. Sir
George Beaumont, defender of all that needed
no defence, admitted to Farington his intention
to campaign against Turner. The summer
Turner probably spent supervising the build-
ing of his house at Twickenham. In the winter
he was ill, went to Yorkshire for a month,
and asked to be excused from giving his
lectures because of 'indisposition'.

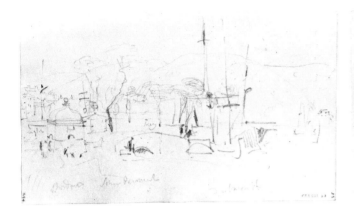

Devon and Yorkshire

In 1813 he returned to Devonshire, a visit well documented by Cyrus Redding, who was editing a local paper. Turner appears in genial mood, enjoying a sea trip that turned everyone else green, talking till late about the Academy and spending the night on a pub chair, providing a picnic for eight or nine ladies and gentlemen – 'in that English Eden', Mount Edgcumbe.

He produced some oil sketches which he was not very pleased with, and many more pencil drawings, including a whole series of those hulks.

The 'Devon Rivers No 2' sketchbook, water

Dartmouth, 53, and a gateway at Farnley Hall 5a, from the 'Devon Rivers No 2' sketchbook

right: Stonehenge, cxxv b, 12. $7\frac{3}{4} \times 8\frac{3}{4}$ ins

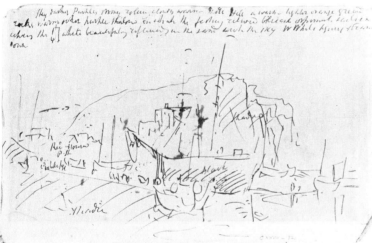

The design for Sandycombe Lodge is one of many that occupied Turner in these years: the house was finished by 1813. It was called Solus Lodge at first, but Turner was not quite solus because his father was always present, helping in every possible way, and, it appears, always cheerful.

Trimmer, the son of a clergyman who took lessons from Turner in return for Latin instruction, described the house as unpretending, with small rooms. There were ship models in glass cases. The Richmond landscape with its stone pines, he said, had been the basis of classical paintings, including the 'Rise of Carthage'. He had a long strip of land so thickly planted with willows ('to refresh his eye') that his father described the garden as an osier-bed. He had a fish pond stocked with trout from the Old Brent River. He chased away boys who came bird-nesting: they called him 'Old Blackbird'. The Turners had two-pronged forks and round-ended knives, and kept a very simple table. Turner was abstemious (his digestion was inclined to acid) and they had only currant wine. He had a boat, and a gig with an old crop-eared horse or pony, which was the model for both the horses in *Frosty Morning*.

'Sandycombe and Yorkshire' is a collection of pages from two sketchbooks of similar size which cannot be separated; but they clearly belong to the same period in spite of the trenchant diagrammatic style of the Scarborough sketches, which makes the Devonshire drawings look rather smooth. Scarborough beach is one of Turner's significant locations – he returns to it again and again.

marked 1812, also contains some Farnley drawings, and there are more in the book called *Devonshire Rivers 3. Yorkshire. Wharfedale*: which title explains how Turner spent the summer of 1813. The drawings are mostly faint – a hard pencil – and many fine pages, even whole sketchbooks, defy reproduction.

A larger sketchbook, *Vale of Heathfield*, taken up again in Sussex in 1816, contains watercolours of the Eddystone Lighthouse by day and by night – these would be poorly reproduced by black and white.

The drawings of Scarborough may date from 1810; Fawkes bought a watercolour in 1811.

At Farnley, Turner bloomed in the warmth of the friendship of his most sympathetic patron. A series of watercolours of the house, the grounds, and the leisured life of the family and their guests, kept him occupied in a somewhat detailed and naturalistic style – using body colour – which was perhaps calculated to please the whole family, not just Fawkes. He could be sure of *his* appreciation. Finberg quotes part of a letter from Fawkes.

By tomorrows coach I shall send you a box containing two pheasants, a brace of partridges and a hare – which I trust you will receive safe and good. We have tormented the poor animals very much lately and now we must give them a holiday.

Remember the Wharfedales (drawings in hand with Turner) – everybody is delighted with your Mill – I sit for a long time before it every day.

What more could an artist ask? He drew

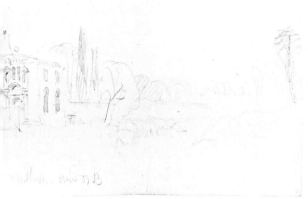

opposite: a picnic on the moors
CXXXIV, 78
below: Leeds, about 1812
CXXXIV, 79, 80. 7 × 10¼ ins

Leeds, perhaps for Whitaker's History of that place, but it was lithographed several years after the first edition, which contained etchings after Turner. The view of Leeds (it surely would have defeated the etcher) was the only lithograph after Turner in his lifetime.

The great *Frosty Morning* was exhibited in 1813. Following *Dido and Aeneas* in 1814 came *Dido Building Carthage* in 1815, his favourite of all his works. *The Decline of the Carthaginian Empire* was shown in 1817 – the pencil in a small Yorkshire sketchbook shows it in almost final form. Except for a visit to a Naval Review at Portsmouth he seems to have been at home in the summer of 1814, perhaps going to Farnley in the autumn. He was there in the late summer of 1815.

this page, top: *Ellenthorpe Ouse BB* (Boroughbridge) *Yorkshire 1* sketchbook, 1815–16 CXLIV, 30

above: *Frosty Morning*, exhibited 1813, oil, 45 × 69 ins. Tate Gallery

below right: 101a, design for *Decline of the Carthaginian Empire*, 1817.

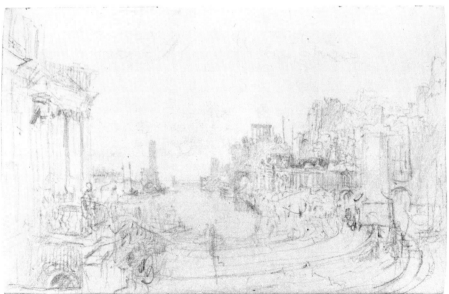

A page from the 'Large Farnley'
sketchbook: *Water . . . Black
Dogs*. CXXVIII. $11\frac{1}{2} \times 18\frac{1}{2}$ ins

right: *Grouse Shooting*,
watercolour.
Wallace Collection, London

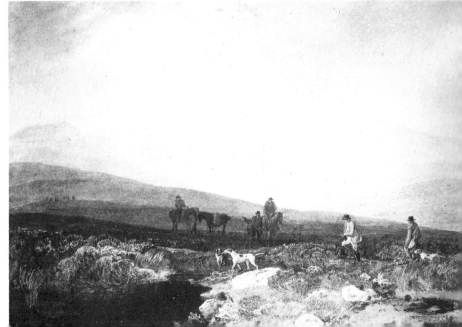

1816(?)

Two pages from *Yorkshire 6*,
CXLIX. 5⅞ × 3⅝ ins
below: Bolton Abbey,
CXXXIV, 74. 7 × 10¼ ins

In the summer of 1816 he spent several
weeks on a thorough exploration of North
Yorkshire and Lancashire, filling the sketch-
books called Yorkshire 2, 3, 4 and 5. He left
Farnley in July in heavy rain which seems
to have persisted for much of the tour – he
and his horse were bogged down in Teesdale,
he wrote to Holworthy. He had a series of
views to do for a projected large *History of
Richmondshire* by Whitaker. A committee of
local gentlemen selected the subjects and the
viewpoints – but they could not influence
Turner's angle of vision and he produced
masterly topographical pieces, sometimes
grandly imposing or sublime, sometimes full
of incident that must have surprised the clients.

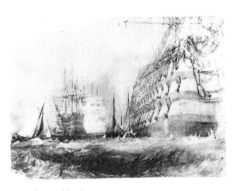

First Rate taking in stores,
watercolour, 1818. Bedford

below: from the *Scarborough 1*
sketchbook, CL. $7\frac{1}{8} \times 4\frac{1}{2}$ ins

He used a restricted palette for the engravers, who rose to the occasion with fine subtle textures and, usually, sympathetic drawing. There is of course much, much more in the four sketchbooks than ever got into the engravings. His style is often finely detailed, with particular care in the representation of trees – at their lush best in a wet summer in the Dales. The fine drawing and hard pencil makes for difficult reproduction. Bolton Abbey was in fact a subject for Fawkes, and the two small pages of shadowed trees may belong to 1818, but they illustrate this new sensitivity.

Two sorts of accuracy distinguish the few pages of a sketchbook called, simply, *Farnley*.

The overgrown coppice of alders or goat willows, and, probably, sycamores, demands his care for line and form; and he has a much blacker pencil now. The library at Farnley has to be correct, since the water-colour will hang in the house. The famous

drawing of men-of-war taking in stores was done at Farnley for a morning's entertainment. Sketches of such a scene were done in the *River and Margate* book, about 1806, but Turner's memory was more use than any amount of notes. The *First Rate* and the Farnley sketchbook can be fairly confidently dated November 1818.

Two pages from a paper-backed book labelled *Scarborough* show Turner at his most original and free: no-one looking over his shoulder.

The library at Farnley Hall and trees by a lake from the *Farnley* sketchbook, CLIII. $4\frac{3}{8} \times 7\frac{1}{2}$ ins

Views in Sussex

This was the title of a series of engravings by W. B. Cooke. The vignette on the title page seems to be engraved by Turner himself. The Vale of Heathfield was one of the subjects, and Finberg gave this name to one of the sketchbooks. The bouncy and attractive group of trees with a castle is not typical of the Sussex sketches of 1815–16; they are practical and finely detailed in the manner of the Yorkshire books of the period – nothing could be left vague in working for the engravers. They wanted detail, and Turner loved to introduce incident and minor symbolism. His plate of *Battle Abbey* showed a hare and a hound in an almost empty foreground – the site of the Battle. He explained this himself, in a unique verbation statement recorded in Edinburgh to mock his London accent: '. . . it is a bit of sentiment, Sir! for that's the spot where 'Arold 'Arefoot fell, and you can see I have made an 'ound a-chasing an 'are'.

A small *Hastings* sketchbook contains some Farnley drawings as well, while a comparatively large book containing the Battle pencilwork, and Hurstmonceux, Pevensey and Crowhurst Park, corresponds roughly to the size and proportions of the engravings, which were, like the Richmondshire series, around $11 \times 7\frac{1}{2}$: the largest he worked for, apart from the Oxford series.

above: group of trees and a ruin from 'Vale of Heathfield' sketchbook, CXXXVII, 60a

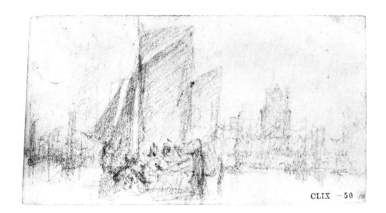

1817: Belgium and Holland

Pages from 'Itinerary Rhine',
CLIX. 2¼ × 4½ ins

Turner had wanted to go to Italy in 1816 – instead he was bogged in Teesdale mud, but very productive all the same. He had a lot of work for engraving on hand, and he was still busy in 1817. He again put off his visit to Italy, but went instead for a shorter trip to Brussels via Ostend, to see the field of Waterloo and then explore the Rhine valley. 'Itinerary Rhine' was described by Ruskin: 'of little value, but has the study for Fawkes' *Dort*'. The study is reproduced above: some of the things he didn't value are below. The book is full of these boldly drawn and, I think, completely charming, everyday things. There are also 30 odd pages of notes for the journey, useful phrases in Flemish, currency

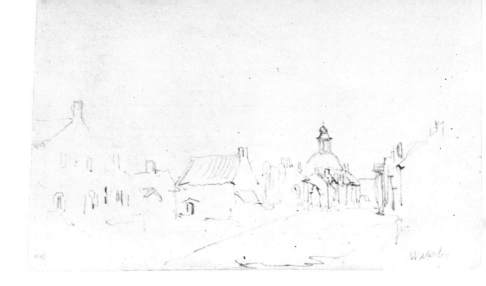

equivalents, and a list, including *Fever Medicine* and *Colors*. Whether he used these colours on the tour is a matter of slight controversy. He lost them on the way back, according to a note in a later book.

His view of Waterloo, some years after the event, was tragic, not heroic. The featureless skies and plains in the sketchbook, and the forlorn village of Waterloo, express desolation though his purpose was quite practical – he was researching for a battle painting. *Causeway down which Bonaparte advanced: Picton killed here: Orchard: 4000 killed: 1000 killed here*, read his captions to a diagrammatic drawing of La Haye Sainte farm.

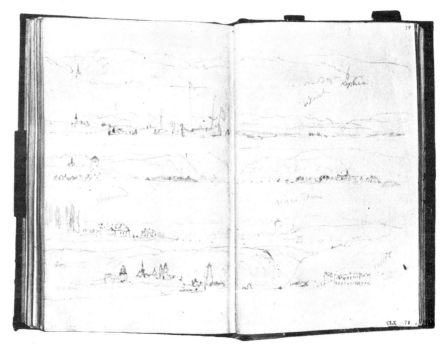

Waterloo and, below, sketches on the Rhine, from the 'Waterloo and Rhine' sketchbook, CLX, 16a and 78a, 79.
$5\frac{7}{8} \times 3\frac{3}{4}$ ins

this page and the next: drawings from the 'Dort' sketchbook, CLXII. 6⅛ × 3¾ ins

On the Rhine he busily collected countless views of towns and castles, including sometimes five or six views on a single spread of the same sketchbook used upright. A larger book, CLXI: *Rhine* contains more formal, sometimes highly detailed sketches of Coblentz, Ehrenbreitstein, Rheinfels, the Katz, St Goar, Bacharach, Ober Lahnstein, Cologne – not a trace of colour, and as far as I can see, different viewpoints from the Rhine watercolours.

Notes in the *Itinerary* book suggest that he was following a sort of brief, perhaps provided by Fawkes: . . . *a league below, towards Cologne Rowland's Keitz Castle – v romantic with Umkel or Unkel . . . Aix la Chapelle. Inn Cour des Londre. Castle of Schonfort 3 miles not remarkable . . .*

The final sketchbook, 'Dort', from Antwerp to Utrecht and back to Rotterdam and Dordrecht, is pure delight in boats, people, and watery places; no more topography.

On his return he produced 51 watercolours; vigorous, colourful, inspired. They were mostly worked into a grey tint background

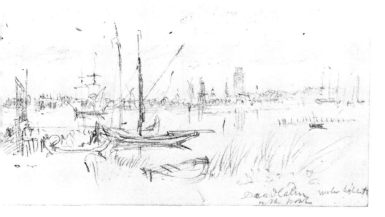

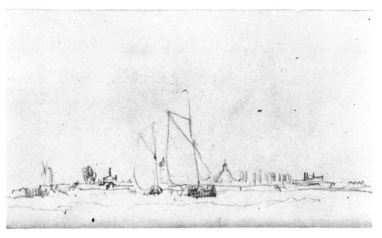

and are not laboured to a high finish. Their sizes, usually less than 9 × 13 inches, and the technique, are consistent with the theory that most of them were begun in a sketchbook of prepared paper, in transparent watercolour and then, on his return, worked up in body colour, with much scraping. Fawkes bought them all.

Two of the Rhine watercolours are well reproduced in Butlin (1962). There are examples at Leeds, Cardiff, Manchester (Whitworth) and Stanford University. Another is in the Fitzwilliam Museum, Cambridge, with a watercolour of the field of Waterloo, also from Fawkes' collection. Three examples are in the British Museum, in the Lloyd Bequest.

left: pages from the 'Dort' sketchbook

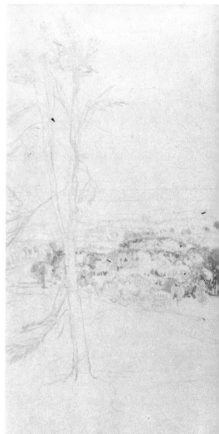

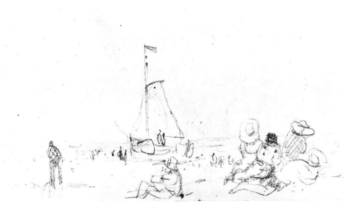

CLVII – 15

Raby Castle and Richmond Hill

The next assignment, which he approached with great care, if not with undiminished vigour after his *tour de force* on the Rhine, was to paint Raby Castle for Lord Darlington and to draw Gibside and Hilton Castle for Surtees' *Durham*. A large sketchbook contains detailed views of these grand residences. A distant view of Raby, in the form taken by the painting, is lightly tinted.

Analytical perspectives of Durham, and scribbles of Newcastle, in a $4\frac{1}{2} \times 7\frac{1}{2}$ inch notebook, *Durham North Shore*, now strike me as later and not connected with the Raby work, even though there are drawings of Bishop Auckland in both books.

The beech trees, *To Raby SW,* show how

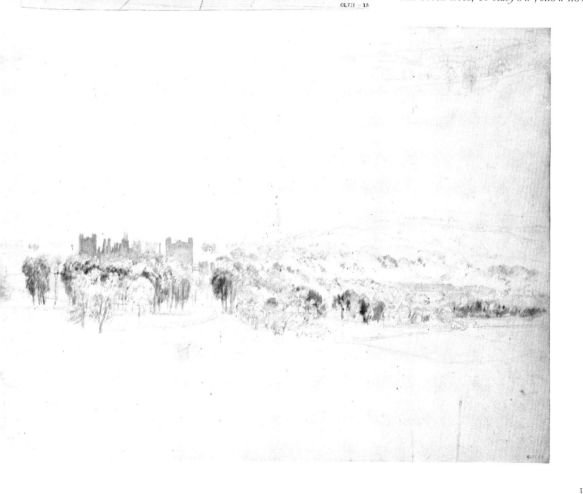

Beech trees, *To Raby SW*,
CLVI, 15a. $9\frac{1}{8} \times 13$ ins

right: Willows and barges on
the Thames: 'Liber Notes'
sketchbook, CXLIII.
$6\frac{1}{4} \times 3\frac{3}{4}$ ins

thorough Turner was in studying the facts of the landscape, whether or not they were a material part of the picture. The motif of two leaning willows with Thames barges looks like the work of another artist, a more intro-spective one than the painter of Raby Castle. His next large project, inspired by no patron, was a large view from Richmond Hill, intended to summarise all his ideas about his favourite river.

Pages from the sketchbook called 'Hastings to Margate' CXL, which Turner also labelled *Richmond Hill*; below: Windsor Castle; right: part of the view from Richmond Hill

The wide landscape emerges by degrees from a mixture of subjects in a small sketchbook which Turner labelled *Richmond Hill. Hastings to Margate*. It seems that he drew the new material for Richmond Hill into a book which already contained notes and verses (*Perfidious Rome*, etc) for *Decline of the Carthaginian Empire* – the figure drawings and the lilies may have been for this. The South Coast drawings, which include Winchelsea

and Rye and Saltwood Castle, may be of 1821, Finberg suggests; but dates the book 1815–16.

The importance to Turner of the picture, *England: Richmond Hill, on the Prince Regent's Birthday* is clear from its enormous width – 11 feet (336·5 cm) – and the number of sketches he made for it. A second, very small, sketchbook, *Hints River,* contains composition studies and a group of figures apparently after Watteau. A watercolour sketch, filed amongst

Colour sketch for *England: Richmond Hill* from the 'Colour Beginnings' CCLXIII, 348

below: pages from *Hints River*, CXLI. $3\frac{1}{2} \times 4\frac{1}{2}$ ins

the 'Colour Beginnings', CCLXIII, establishes the grandeur of the conception. The figures, grouped in a chorus at the left, suggest a pagan celebration of the majestic view. The idea of the Prince Regent's birthday gave the excuse for a large gathering of richly dressed people and added the dimension of national pride. Amongst the earlier group of 'Colour Beginnings', CXCVII, is an accurate watercolour of the river view from Star and Garter Hill, with all the saturated colour of a modern colour photograph.

Further 'hints' in the small sketchbook suggest the possibility of a different River apotheosis, with a rainbow and several-arched bridge – both powerful themes of Turner's.

Skies

One of the most remarkable and beautiful of Turner's sketchbooks is that containing 65 watercolour studies of clouds. Some sort of comparison with Constable's cloud studies seems to be suggested – they had met and talked by this time (in 1813, at a dinner). Turner's collection of skies is certainly not as scientific as Constable's – it is more a series of cloud poems. As with others of Turner's sketches in series, no selection seems to work: but a further six pages will be found in *Turner's Colour Sketches* (1975) where I misguidedly tried to redate the book to 1820, much to John Gage's scorn in a review.

A last look at Turner's River comes from the 'Aesacus and Hesperie' sketchbook of 1819; and Turner has the last word, if you can read it.

1818

In 1818, Fawkes' *Dort* was hung in the Academy Exhibition, as also was *Raby Castle.* Wilton describes *Raby* as 'the last and grandest of Turner's house portraits in the eighteenth-century tradition'. *Dort or Dordrecht: The Dort packet boat becalmed,* while based in tradition going back to Cuyp (and carefully worked out on golden sections) was, then and now, like a bright window into a new world.

from the *Skies* sketchbook, CLVIII, 19; and right, from 'Aesacus and Hesperie' CLXIX, 25a, 26. Page about $3\frac{1}{4} \times 4\frac{5}{8}$ ins

He produced ten drawings for a *Picturesque tour of Italy* based closely on camera lucida drawings by an architect, Hakewill: but still did not go to Italy. Hakewill provided notes for his journey the following year. Besides these previews, Turner painted a large water-colour, a *Landscape: Composition of Tivoli*, exhibited in 1818.

Engraving after Turner, after Hakewill.

Double spreads from *Scotch Antiquities,* CLXVII, 84a, 85 and *Edinburgh 1818,* CLXVI, 61a, 62

A hurried visit to Edinburgh in October 1818, to find material for engravings in *Provincial Antiquities of Scotland*, for which Walter Scott was to provide the words, resulted in some brilliant pencil sketches on which were based most of the watercolours for engraving. Scott had the watercolours instead of a fee. The artist returned via Farnley: see p 138.

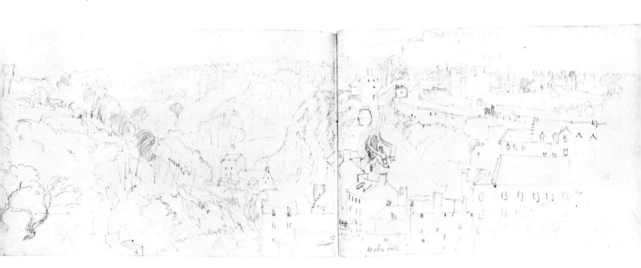

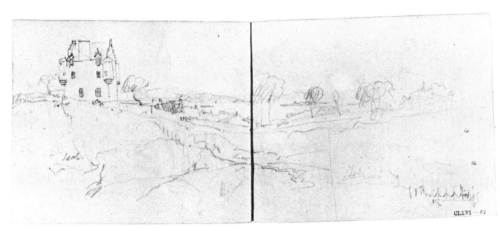

Of 22 sketchbooks used on the journey and in Italy sixteen are of the average size, $4\frac{1}{2} \times 7\frac{1}{2}$ inches approximately, which we have often mentioned. They have usually about 90 leaves, both sides drawn on; sometimes two or three subjects to a page, sometimes two pages to a subject: a total of 1966 drawings, many of these being multiple subjects. Four larger books were prepared with a grey wash, usually on one side of the leaf, the other being left

CLXXIII, 10
CLXXI, 17a, 18
CLXXIII, 21
CLXXVII, 3a

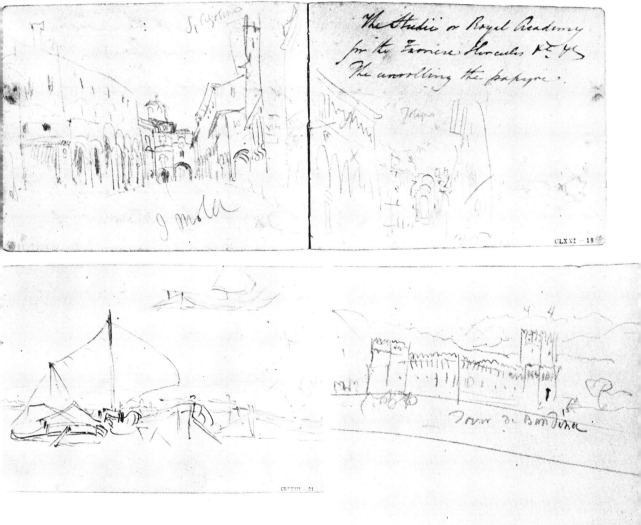

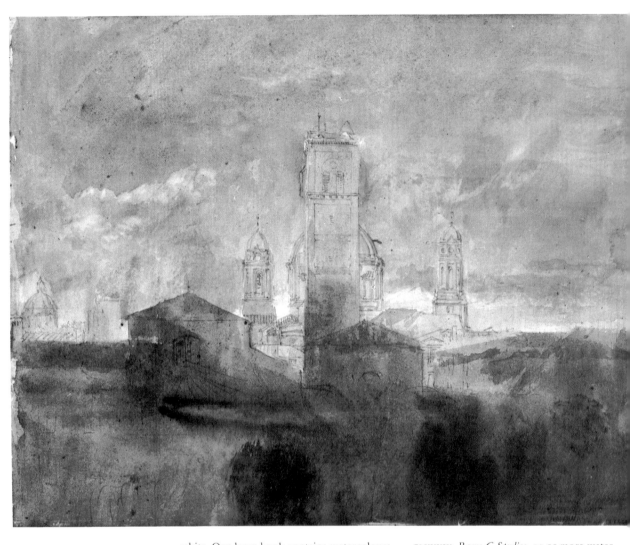

The 'Como and Venice' sketch-book: CLXXXI, 3: view, perhaps from a hotel window, in an Italian town. $8\frac{7}{8} \times 11\frac{3}{8}$ ins

white. One large book contains watercolours on white paper only – the *Como and Venice* book illustrated here. One more small book, *Passage of the Simplon,* has dark-tinted paper. The larger sketchbooks are:

CLXXXI *Como and Venice.* 55 in colour, one pencil page, $8\frac{7}{8} \times 11\frac{3}{8}$ (above).

CLXXXIII *Tivoli.* 51 pencil on grey with lights removed, 5 pencil on white, 10×8.

CLXXXVII *Naples, Rome C Studies.* 16 water-colours (or more – they are mounted separately) on white and on grey, and pencil drawings 54 in all, 16×10 (p 157).

CLXXXIX *Rome C Studies.* 22 or more water-colours and mixed media, the rest pencil on grey with rubbed, scratched or wiped lights. 61 in all, $14\frac{1}{2} \times 9$ (pp 156, 158).

CXC *Small Roman C Studies.* Some watercolour most pencil on grey, $5\frac{1}{4} \times 10\frac{1}{8}$.

Much unfinished work in these books is of great interest, and Turner was clearly in his most experimental frame of mind, or, some-times, in his most serious. He was not con-cerned to produce a consistent series, such as he had done on the Rhine, though the

CLXXXI, 7. Campanile and
Doges' Palace, Venice

monochrome chiaroscuro studies of Rome
and Tivoli do make a consistent group, with
all the gravity of the Scottish Pencils of twenty
years before. I am not sure whether these
studies were meant to be, possibly, coloured
later, and I cannot accept that Finberg's
'chiaroscuro studies' was a term used by
Turner – though it is a useful description.
His purpose in all these Italian sketchbooks
seems to have been to learn and explore.
Perhaps instinctively, in many colour sketches,
he appears to be trying to get away from the
too meticulous style of the Farnley interiors

and the work for engraving of 1818. In some
watercolours he seems to be struggling; adding
ink and gouache; others he gives up after a
few broad brush strokes or a carefully modelled
section. Several others, of course, are perfect
of their kind: and they *are* sketches.

The work in the small pencil books varies
from exuberant, rapid 'travelling' sketches to
quite painstaking architectural drawings.
Architecture is indeed his obsession in the
Italian books, whether it is a glimpse of a
picturesque town square, an accurate note of
an important cathedral, or the fluent and

153

poetical renderings of townscapes in Venice and Rome. He seems to have ignored nothing: he was the complete tourist, eager to see churches and pictures, Pompeii, treasures of the Vatican (of which he filled 50 pages, with catalogue numbers). But I cannot bear out the comments of some authors that the sketch-books are 'full' of (a) people, (b) notes on colour. Out of all the drawings, 64 pages contain figures (leaving out sculpture) and

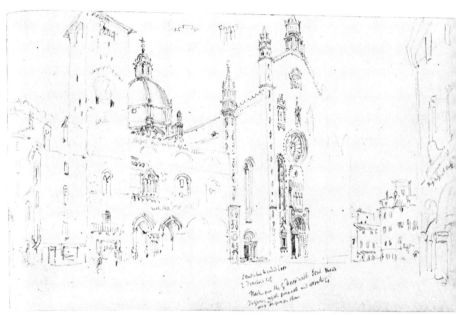

1819

CLXXIV, 62a, Como Cathedral and 31, Turin(?). $4\frac{3}{8} \times 7\frac{3}{8}$ ins

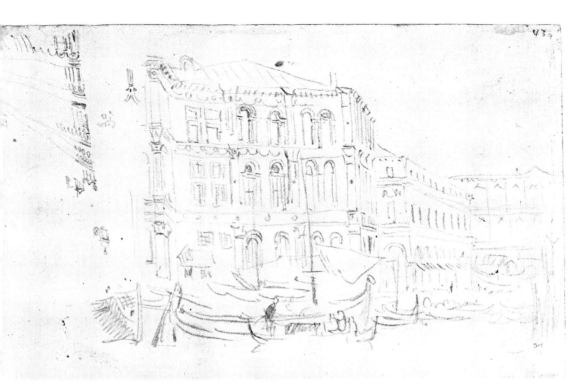

The Camerlenghi Palace, Venice;
below: S. Giorgio Maggiore.
CLXXV, 43a and 61. 4¾ × 7½ ins

there are only 19 verbal references to colour, mostly describing pictures, and including a long description of a scene in terms of *Wilson/ Claude*. There are 28 references, including rough copies of pictures, to painters, ten of these to Claude, four to Wilson. Inscriptions are frequently noted in detail, and boats whenever he sees them. But that still leaves nearly 1900 buildings, gardens and landscapes, few of these in the countryside.

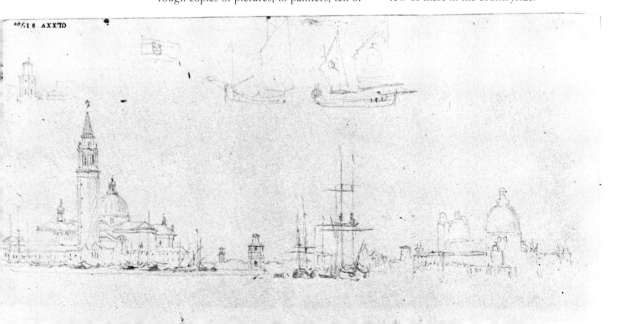

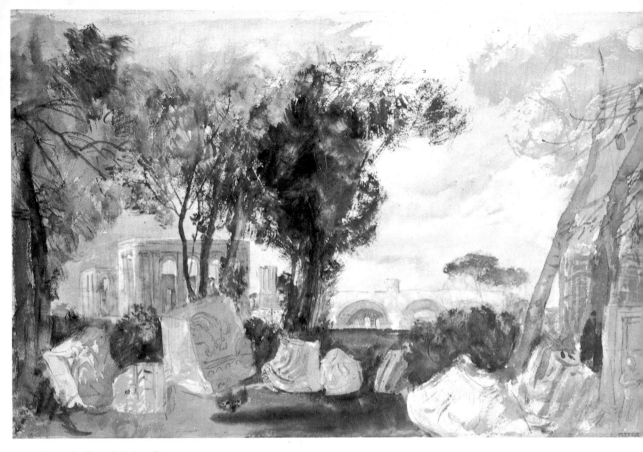

From the *Rome C Studies* sketch-
book: CLXXXIX, 30. Rome.
14½ × 9 ins

CLXXXII: 8a *Lago Albano* 9 *Albano.*

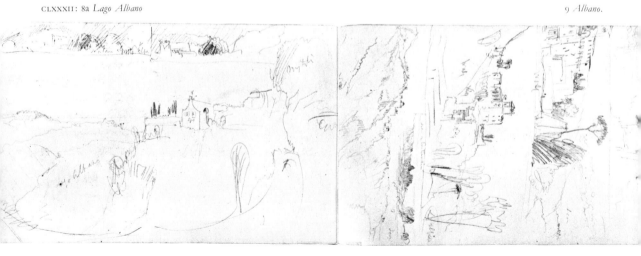

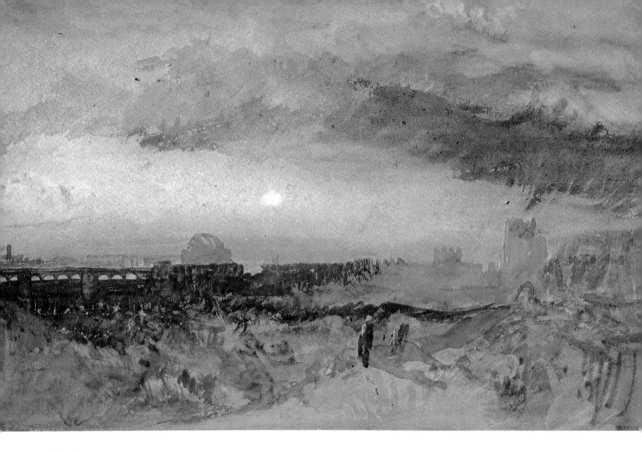

CLXXXIX, 36 The Claudian
Aqueduct

65a, 66. The Forum, Rome from the *Albano Nemi Rome* sketchbook, page size $4\frac{3}{4} \times 7\frac{1}{2}$ ins

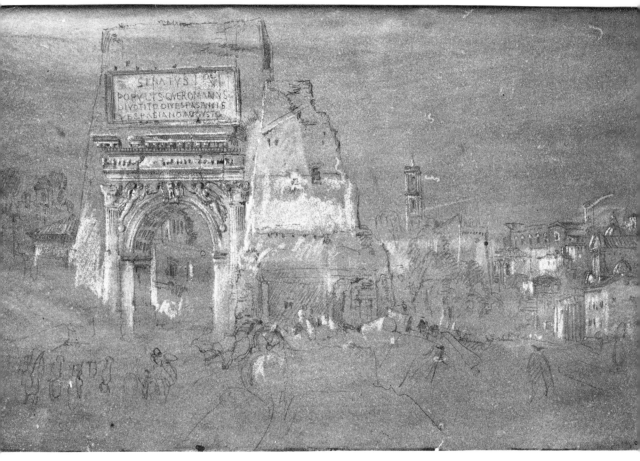

Surely no traveller to any city ever made so generous a response. The two pairs of pages overleaf, from the *Albano, Nemi Roma* sketchbook are, I have no doubt, works of high art, small and in common graphite though they be. Their easy authority might suggest they belong to a later visit, in 1828, rather than being four pages out of so many first impressions. But, uncharacteristically, Turner dated the book on the cover: *Nov 30, 1819,* and again on another three pages of Albano: *Novr 19, 1819, Novr 10, 1819* and *11 Novr 1819.* He had been in Rome perhaps a month.

With energy unabated from *the first bit of Claude* at Loretto to the *Tivoli and Rome* book – the design for *Rome from the Vatican* appears here, and a *Grey Castle. Claude* – he works through eight books of pencil work to *Rome*

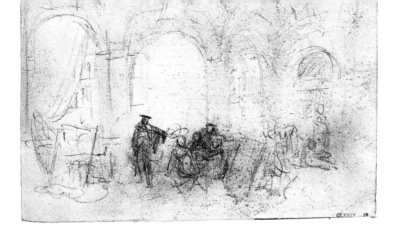

opposite above: from *Rome C Studies,* a monochrome drawing on grey-washed paper, CLXXXIX, 43. Arch of Titus.

Opposite, below: Copy of a Claude, from *Rome and Florence* sketchbook, CXCI

above: sketches from CLXXIX, *Tivoli and Rome* sketchbook

and Florence where we find the copy of a Claude harbour piece, reproduced here. In the book *Return from Italy,* a mountain lake is *Like Wilson.* People at *Turin* wear *Brown shawls, white caps, striped gaiters.* In the wintry mountains: *Fog rising. Some Shadows darker* [blue?] *than the Blue sky. Cloud warm.*

He hurried back to London in January, too impatient to wait for a mountain pass to be cleared of snow. His carriage overturned: later he did a watercolour of the incident for Walter Fawkes.

Every glance is a glance for study, he told his lecture-room audience, with his inimitable phraseology. It might have been his motto: he applied it equally to the infinite variety of nature and to the works of man. No selection can do justice to the record he left of *his* study.

from cxcii *Return from Italy*